MANET

SANDRA ORIENTI

THAMES AND HUDSON

Translated from the Italian by Caroline Beamish

Published in the United States in 1989 by Thames and Hudson Inc.,
500 Fifth Avenue, New York, New York 10110

Library of Congress Catalog Card Number 89-50753

Printed in Italy

Life

Edouard Manet, who was destined to defy tradition and overturn convention, was born into a highly respectable French bourgeois family. His father, Auguste, was a senior official at the Ministry of Justice; his mother, Eugénie Désirée Fournier, a sensitive, well-educated woman, was the daughter of a diplomat.

Edouard was born in Paris on 23 January 1832, at 5, Rue des Petits-Augustins (now Rue Bonaparte). In 1839 he was sent to the establishment of Canon Poiloup, in Vaugirard, as a weekly boarder, and in 1840 entered the Collège Rollin; in about 1845, on the advice of his uncle, his mother's brother, he joined the drawing class provided by the Collège. When he left school in 1848 his father, who was keen to obstruct his inclination towards painting, offered him the choice between a career in public service or a career as a naval officer. He chose the latter, but he failed the entrance examination; nevertheless he set sail as an apprentice pilot on the *Guadeloupe*. In 1849 he was in Rio, where he filled his notebooks with drawings and sketches; in the July of that year he failed the entrance examination for the second time, and this time was told that he would never be able to join the navy.

He returned to Paris and his father agreed to allow him to follow his vocation and to become a painter. This was in 1850; Manet attended the painting classes held by Thomas Couture. He threw himself into his new life with tremendous enthusiasm, supplementing the work done in Couture's studio with frequent visits to the Louvre and other galleries, where he made careful copies of paintings by his favourite painters, Titian and Velázquez. He made trips to study in Italy in 1853 and 1856, and went to Holland, Germany and Austria in the same year. Meanwhile, according to Antonin Proust, Léon-Edouard Leenhoff was born on 29 January 1852, son of Manet and Suzanne Leenhoff, his brother's piano teacher who was a year older than he was. In 1855 the conflict between Couture's teaching and

Manet's new ideas became acute; to the astonishment and admiration of his co-students Manet left Couture and rented his own studio, and that moment was effectively the beginning of his life as a painter.

In 1857, when he was working at the Louvre, Manet met Fantin-Latour, and at the same period he and his friend Antonin Proust paid a visit to Delacroix. Later, in 1860, he was to meet Baudelaire, with whom he remained friends over a long period. In 1859 *The Absinth drinker* was refused by the Salon, even though Delacroix had spoken in its favour. During this time Manet's friendship with Baudelaire stimulated his enthusiasm for Spain, and this was enhanced by his seeing the company of Spanish actors and dancers who were performing in Paris at the time. In 1861 he made his début at the Salon with *The Guitarist*, and the painting won him an honourable mention.

Manet's father died on 25 September 1862 and left his son a moderate fortune; during the same year he met Victorine Meurend, who was to be his friend and highly prized model for many years. At the beginning of 1863 Manet was preparing a one-man show at the Louis-Martinet gallery. But in April the jury of the Salon refused the three paintings that he had submitted, and these were exhibited in May in the Salon des Refusés. On 28 October of that year he regularized his union with Suzanne, marrying her in Holland, at Zalt-Bommel.

Manet did not think it would be wise to send so daring a work as his *Olympia* (*pls 13-15*) to the 1864 Salon, so he compromised by sending two paintings instead, *Bullfight* and *The Dead Christ with angels* (*pl. 16*). *Olympia* was accepted for the 1865 Salon, and created a tremendous scandal. When the fuss had died down, in August, Manet left for Spain where his admiration for Velázquez was confirmed and where he first came to know the paintings of Goya. In 1866 he was turned down by the Salon again; but his circle of friends was now increasing and Manet was the centre of lively gatherings, either in his studio or at the Café Guerbois, which included Antonin Proust, Fantin-Latour, Bazille, Nadar, Astruc, Duranty, Silvestre and Degas, Monet and Cézanne; he was also a friend of Zola, who predicted that he would have a work in the Louvre some day.

4

At the Salon of 1867 Monet showed *Camille*, and some critics discerned the influence of Manet in it; this gave rise to André Gill's quip: 'Monet or Manet? Monet. But we owe this Monet to Manet. Well done Monet, thank you Manet'. In 1868 Manet's *Portrait of Emile Zola* (*pls 33-4*) was accepted by the Salon; that summer he painted *Luncheon in the studio* (*pls 37-9*). He met Berthe Morisot, who was to be a frequent visitor, and who posed for *The Balcony* (*pls 41-2*), exhibited at the Salon of 1869. At the same period Eva Gonzalès became his pupil and often posed for him. The Salon of 1870 accepted two paintings by Manet, and he also figured there in Fantin-Latour's painting, *Studio at Batignolles*, though this 'allegorical triumph', as it was sarcastically called, did not pass without ironical comments. During the Franco-Prussian war Manet served in the artillery with Degas, first as a gunner and then as sub-lieutenant under Colonel Meissonier. At the end of this year the dealer Durand-Ruel bought paintings by Manet on three different occasions for a sum which exceeded fifty thousand francs. In August 1872 Manet went on a trip to Holland where he especially admired the work of Jongkind and Frans Hals.

The 1873 Salon accepted *Le Bon Bock* and *Repose* (*pl. 44*), and both were successful. The following year, however, only *Gare Saint-Lazare* (*pls 51-2*) was accepted, and Mallarmé, who had become a friend of Manet, protested in vain against the refusal of the other works he had submitted. During the spring of this year Manet had turned down an invitation to take part in the first impressionist exhibition, held in the gallery of the photographer Nadar, in spite of pressure from Degas and Monet. Nevertheless he spent that summer with Monet at Argenteuil and in September went to Venice. On 22 December Berthe Morisot married Eugène Manet, the painter's younger brother.

The painting entitled *Argenteuil* (*pl. 54*) created an uproar in the Salon of 1875; Manet was once more excluded completely in 1876 and prepared to hold an exhibition in his own studio, on the door of which he pinned a notice 'Faire vrai et laisser dire' ('Paint the truth and let them say what they like'). In 1877 *Nana* (*pl. 62*) was refused, on the pretext that it was immoral, and was then exhibited

in the window of a junk shop. 1878 was a difficult year for Manet: he was compelled to withhold any paintings he might have wanted to show at the Exposition Universelle, and instead he planned to have his own private exhibition, but this did not come off. Two of his paintings were accepted by the Salon in the following year, and he exhibited *The Execution of Emperor Maximilian* (*pl. 32*) in New York, but with little succes. During this year the first alarming symptoms of the disease which was eventually to kill him (locomotor ataxia) manifested themselves. At the end of March 1883 Manet was still at work, on the pastel *Portrait of Elisa*; but on 6 April he went to bed for the last time. Gangrene had attacked his left leg and an attempt at amputation was unsuccessful. On 30 April, at seven in the evening, he died in the arms of his friend Chabrier at 7, Rue de Saint-Pétersbourg; he was buried in the cemetery in Passy on 3 May.

Works

' He was greater than we ever thought. ' When he murmured these words on his way out of the cemetery in Passy, after Manet's funeral, Degas summed up the course of his friend's life in a single sentence. He consistently rejected everything established by convention – the slavish reproduction of nature, moral or social significance, history and anecdote, the exaltation of beauty, the geometrical treatment of space. In their place, to the confusion of the public and critics alike, and sometimes apparently beyond the intention of the painter himself, Manet proposed an alternative to traditional and academic art. His alternative was not an alternative subject, although is seemed so to most of his contemporaries, but an alternative form. His so-called realism is an obvious trap, appearing as it does to re-incarnate Courbet and his circle; in fact this realism springs from his free interpretation of visible objects and his desire to transcend the outward appearance of the object in order to possess it completely; by an immediate translation of the object into his own terms, he produces an image which is entirely personal. It was in this realm of pure painting, far more than in his much discussed choice of subjects, that Manet affirmed the rupture between living art and official, bourgeois art.

Considering what kind of a painter Edouard Manet was to become, it may seem strange that he should have spent so long in the studio of Thomas Couture, those six long years which Zola afterwards described as a long period of frustration. If it is really true that Manet brought about a clean break with tradition and was the initiator of the artistic period in which we are living now (Boccioni indicated that this was so as early as 1914: ' There is no trend in painting or sculpture today, in Europe or in the whole world... which does not originate in French impressionism, from Manet to Cézanne '), then the years spent with Couture seem an unlikely choice. It is true, however, that for a young man desirous of taking up the artistic life, the choice of names at the time was extremely limited; and the Ecole

des Beaux Arts, with its handful of professors for whom the painting of Ingres was still the only example worth following, and with its rigid academic system of teaching (to the pupils of the Beaux Arts, as Delacroix scornfully observed, ' beauty is taught like algebra '), did serve as a kind of testing ground for each pupil's private initiative and desire for independence. Couture, though he appeared to despise both Ingres and Delacroix, in fact used teaching methods which drew fairly heavily on the style of Ingres; he concentrated his energies on idealizing his model, studying and analysing it in great detail, and in his historical paintings this had the unfortunate result of depriving it of any overall unity.

When he left Couture's ' official ' studio he had received a rigorous training for his chosen trade; he shared his master's admiration for painters such as Titian, Tintoretto and Velázquez, but he abhorred the theatrical quality of most of Couture's own compositions. Now for the first time he was faced with contemporary reality, with the world seen with his own eyes and assimilated directly into his own mind, and he applied himself to becoming part of this world, to absorbing it and representing it in the first flush of his artistic career. It is significant that during this period he underlined a sentence in a work by Diderot: ' One must belong to one's own time and do what one sees being done. '

Passionate, reckless, and with a great sense of humour, ready to try anything and to oppose any false rhetoric, ready to take up the most extreme position if his instinct told him to do so, possessed of acute intelligence and imagination, a shrewd psychological sense and unbounded curiosity, Manet did not take a public stand against society; his battle was fought from the inside, from the very heart of the society against which it was directed, and from this position he upheld the validity of the discoveries he had made which consisted, basically, in defending the cultural values of modern life.

When he and Antonin Proust made their visit to Delacroix' studio it was partly out of sincere admiration and curiosity and partly to ask his permission to copy his *Dante and Virgil in the Inferno*; this visit was not the starting point for a new movement or anything like that, but it can be

seen as a kind of fitting homage paid to one of the key figures in French painting.

At the Louvre some of Manet's sources can be pointed to with absolute certainty, since we know what care he lavished on his copies of pictures by Titian, Tintoretto and Velázquez; and on his trip to Florence (1853) he made copies of paintings by Titian, Fra Angelico and Filippino Lippi. When he submitted *The Absinth drinker* to the Salon of 1859 (it was turned down by a negative vote from Couture, against which the support of Delacroix was useless), it seemed, purely on academic analysis, to have been constructed in support of simplification and sparseness of composition; its realism is full of literary overtones, in particular echoes of Baudelaire who was later to infiltrate Manet's work even more thoroughly. On the other hand the painting has certain affinities, pictorially, with Spanish paintings of the seventeenth century; these can also be detected in *Boy with sword* (*pl. 4*) and *Boy with cherries* (*pl. 1*). In the *Students of Salamanca* (1860), beneath the shady branches of the French trees lurks a discreet touch of Spanish humour.

Baudelaire has been accused at times of failing to understand the real nature of Manet's talent, but in spite of this he was one of the first to uphold its originality in the face of malicious criticism. In 1864 the critic Thoré wrote: 'Manet has the powers of a magician, brilliant light effects and garish colours in imitation of Velázquez and Goya, his favourite painters'. Baudelaire replied: 'Manet, who is thought to be mad and wild, is in fact a forthright, extremely simple man. It is wrong to say that he imitates. M: Manet has never seen the work of Goya or... El Greco. It may seem incredible, but it is true... He has now heard so much about his pastiches of Goya that he wants to see some Goyas. He has seen some Velázquez, I am not sure where.' Manet in fact had been fascinated by Venetian and Spanish painting; he was stimulated by almost every kind of painting, including the work of some of his contemporaries. Even though he did not see any of Goya's pictures until his trip to Madrid in 1865, he had seen and admired Velázquez' paintings in Parisian collections and in fact had copied the *Little Horsemen*, and made an engraving from it.

Notwithstanding his downright rejection by the Salon of 1859, Manet took up his brushes again with renewed vigour. *Boy with cherries* was painted at this time; this is a bold piece of design, with the boy's surprised face peering out of the bright mass which represents his head; the colours are sharply contrasted and the painting has the humour of a slice of life. The sense of identification with the subject here is something quite new, and it is achieved by concise, formal means. Manet's career is to a great extent bound up in the history of the Salon: he was constantly acutely aware of the need to show his work and to have it recognized in that institution, which he considered to be the most suitable place for it; he assumed that the Salon would be the place where he would gain most public and critical acclaim and where he would achieve the success that he yearned for all his life. So although on one hand his self-respect would not allow him to make any but the slightest compromise in his painting, on the other hand the regularity with which he submitted works to the Salon clearly showed that he wanted to establish a position for himself even in official circles.

The Salon of 1861 accepted *Manet's parents* (*pl. 3*) and *The Guitarist* (*pl. 2*) and at first they were hung in a dark corner; however, when they received favourable criticism they were re-hung and won an 'honourable mention' for Manet, possibly thanks to the support of Delacroix. The quality of the picture of the Spaniard, and its enthusiastic reception, created an atmosphere of sympathetic understanding around Manet, and now a group of artists including Legros, Fantin-Latour and Braquemond gathered round him. He amazed them by announcing what the catalogue had not revealed, that he was a pupil of Couture. Later on, ' the painters introduced him to a poet and various art critics '; the poet may have been Baudelaire, and the critics perhaps Castagnary, Astruc, Desnoyes, Champfleury, Duranty, Gautier, all of whom had appreciated Courbet and supported him and now saw Manet as a valuable recruit to their circle. Although Courbet treated him with a kind of guarded irony, Manet would no doubt have been very welcome in the Brasserie des Martyrs if his bourgeois origins, the caution with which he regarded

artistic revolutions, noisy and strident as they were, his preference for the pleasant life of a *mondain* rather than the instability of Bohemian life, had not attracted him to the pavement tables of fashionable cafés rather than to taverns and beer cellars. From his café seat he could watch the coming and going of the elegant, capricious Parisian women.

When Victorine Meurend came both into his studio and into his life in 1862, Manet at once began to use her as a model for his Spanish paintings; these paintings are filled with a kind of exoticism, never an end in itself, and though they represent contemporary scenes they have a very broad cultural basis. Local colour was added, in Paris at that period, by the presence of all kinds of Spanish troupes, of actors, singers, dancers and bullfighters. There were too many of them, performing extraordinary feats in the most exotic dress, for Manet to use all the seductive possibilities they offered him.

The flame-coloured clothes, the savage and beautiful attitudes of the dancers, their sparkling vitality and the picturesque quality of their movements, the extraordinary personalities which some of them possessed, or which Manet conferred upon them, all contributed to Manet's enthusiastic acceptance of the Spaniards as his subjects; they seemed to him to be exactly what he needed as vehicles for his present style, rooted as it was in Spain and the Spanish temperament. At this period he painted *Mademoiselle Victorine in the costume of an espada*, the *Spanish Ballet* (*pl. 9*), and *Lola de Valence* (*pl. 8*); also the *Young man dressed as a Majo*, for which his brother Gustave was the model, and th *Matador*, a portrait of his other brother Eugène.

Victorine, in her elegant costume, stares from the canvas with a bold, slightly surprised expression; her figure, painted in black, stands out against the sunlit arena, the slightly tiresome pose somehow modified by the depth of colour used and the solidarity with which it is applied. On the right, in the background there is sketched a reference to one stage of the bullfight, its technique contrasting vividly with the sober painting of the *espada*: the bullfighting scene is painted with rapid brushstrokes, which suggest most economically the violent movement involved, and the spec-

tators behind are painted in the same way but are represented simply by the alternating black and white of their garments. In *Spanish Ballet* the placing of the models, spread about in symmetrical relationships, gives the picture a theatrical quality. Lola, Don Mariano Camprubi, all the members of the troupe are there. The tavern is not painted in very great detail, but there is enough to make it seem lifelike; the halo of light which makes the dancing floor look so spacious also divides the painting up into carefully observed portions: the guitarist sitting thoughtfully by himself, and the principal dancer, Lola, slumped on a chair, her eyes distracted by the steps of the dance.

At this period Manet singled out Lola from the troupe for his special attention. Strong features, distinguished nose and sensual mouth upturned in an overpowering smile; gaudy clothes, heavy legs with fine and nimble feet, round arms, delicate hands; the arrogance of a woman of the theatre used to dominating the boards. Lola stands in the wings, brilliantly lighted, whilst in the theatre, in the background, hundreds of people are sitting waiting, watching Lola's shadow on the boards in a tremendously heightened state of tension. Baudelaire wrote a quatrain for the presentation of *Lola de Valence* at the Martinet gallery in 1863, in which he identifies the poetic essence of the painting, its inner unrest, ' the unexpected charm of a pink and black gem '.

> Entre tant de beautés que partout on peut voir
> Je comprends bien, amis, que le désir balance,
> Mais on voit scintiller en Lola de Valence
> Le charme inattendu d'un bijou rose et noir.

In the early months of 1863 Manet exhibited a fine group of recent paintings including the *Street singer*, the *Young woman reclining in Spanish costume* (a homely, sociable version of a Maja) and *Music in the Tuileries* (*pls 5-7*). This was the first of Manet's paintings dedicated to the ardent atmosphere of ' la vie moderne '. Contemporary life is exalted here not only in the fact that some of the people can be recognized, but because Manet has seized a scene from everyday life and set it down without any thought of

telling a story or including allegorical undertones; he has captured the worldly gaiety of Parisian leisure, and has painted it with only the slightest hint of irony beneath his gaiety, his eyes closed to anything beyond the shady garden.

The critics who were generally quite kindly disposed to new artistic developments unanimously saw the paintings exhibited at Martinet's gallery as ' a striped banner of red, blue, yellow and black which mocks the very essence of colour itself '; and they can hardly have felt disposed to support Manet's cause in front of the jury of the next exhibition, the Salon of 1863.

That year the jury were so stringent in their requirements that even painters whose work had been accepted on previous occasions or, as in Manet's case, had won honourable mention in earlier Salons were turned away. Dozens of paintings were rejected, and the preliminaries to the exhibition were so stormy that Napoleon III was forced to the decision that works not accepted should be shown in another part of the Palais de l'Industrie (which had housed the Salon since 1855). Some painters accepted the jury's judgement and withdrew their paintings but most of them in fact were delighted with the opportunity to hang their pictures in competition with those officially accepted.

Manet and his friends readily accepted the idea of a Salon des Refusés, particularly as it spared them the disgrace of withdrawing their paintings completely. Manet himself continued to regard the Salon as the only place really fit to exhibit in, but he hoped that the success of the Refusés would be so great that the Salon procedure for selection, with its jury, would be abolished. Courbet and his circle had hoped for the same thing. The Parisian public found the Salon des Refusés a great occasion for merriment: visitors thronged to see the paintings, especially on Sundays, and the gallery was filled with their derision and laughter. Manet showed three paintings: *Young man in Spanish dress, Mademoiselle Victorine in the costume of an espada* and *Luncheon on the grass (pls 10-12)*, which was called *Bathing scene* in the catalogue.

The first two of these revived the use of violently Spanish subjects, and Spanish clothes and manners gave them their

13

bright colours and their brash, heraldic composition; the third painting had already been called indecent by Napoleon III, and it was to come in for more jeers and cries of derision than any other. The English critic P. G. Hamilton concluded that a nude, painted by a vulgar man, is inevitably indecent. Manet had found his subject for *Luncheon on the grass* in a composition by Raphael, which he knew from a print by Marcantonio Raimondi; more obviously, as his contemporaries recognized, the plan of the picture is borrowed from the *Pastoral Concert* in the Louvre, attributed to Giorgione.

What really caused the scandal was Manet's presentation of two gentlemen sitting in a wood, dressed in city dress, conversing quite respectably, with a completely naked woman sitting beside them and another in her shift lazily getting out of a pool nearby. The susceptibilities of the public were offended by seeing two such modern and recognizable gentlemen in the company of two such immodest ladies; the critics on the other hand were shocked by the novelty of the picture and by the liberties Manet had taken with technique. He largely discarded half-tones and subtle gradations of light and shade, and the objects and figures are painted in very flat colours which are placed in unusual juxtapositions; the shapes are thus expressed in colour rather than by sharp outlines and are seen in a new relationship with one another. After the stormy spring of 1863 Manet continued his work with increasing devotion; a still-life with fruit and fish using the same colour technique as *Luncheon on the grass* dates from this period, and there are a number of small canvases also of this date, showing peonies in full bloom, their petals stiff and dense, painted with the same compact, flat colours and brilliant sensuality (*pl. 21*). In the autumn he painted *Olympia* (*pls 13-15*) with Victorine as his model. He withheld *Olympia* from the Salon of 1864, sending instead a *Bullfight*, painted from his imagination, and *The Dead Christ with angels* (*pl. 17*). The jury, more liberal than the one of the year before, accepted both. Baudelaire, without Manet's knowledge, recommended that they should be hung in a prominent position and this gave rise to the argument between him and h friend Théophile Thoré, alias W. Bürger.

The Salon of 1864 was not of great moment for Manet, except perhaps for a psychological reaction precipitated by the constant attacks against him. He destroyed the *Bullfight*, so that now only two fragments of it remain, *Incident in the bullring* and the *Dead Toreador* (*pls 18-19*) which, though the figure of the corpse is rather stiff, is redeemed by its fine colouring. The black silk of the costume sets off the white shirt and stockings and the very pale pink of the *muleta*, all against the brown of the bullring. In June of this year something happened, connected with the Civil War in America, which immediately attracted Manet's attention: off the coast of France near Cherbourg a Confederate privateer was attacked by a much bigger Federal corvette. Manet rushed to the spot and witnessed the battle, making sketches which he used in a painting, *Alabama and Kearsarge*, which was exhibited at Cadart's shortly afterwards.

The Salon of 1865 was one of the most severe Manet was to encounter. The jury, more or less the same collection of people as the previous year, had admitted him, perhaps in the tacit hope that another failure would be the end of him. All the paintings were hung in alphabetical order, those of Manet being placed beside those of Monet, and because the signatures of the two painters somewhat resembled one another Manet was congratulated over and over again for paintings that were by Monet: he commented bitterly ' I have been congratulated only for pictures that are not mine '. He had submitted two paintings which had aroused such bitter criticism and violent attacks that he had gained more notoriety, as Degas pointed out, than even Garibaldi. One picture was an *Ecce Homo*, the other *Olympia*; the latter, of course, aroused the most angry opposition. Paul de Saint-Victor's comment, in *La Presse* of 28 May, seems to sum up the disgust of public and critics alike: ' People throng in front of Manet's putrid *Olympia* as they would in front of a body in the Morgue. This is art fallen so low that it is not even worthy of censure '.

Manet had painted *Olympia* nearly two years earlier, and his hesitation to show the painting publicly may have been due to fear of giving such an opening to his ill-informed and vicious critics. When at last he submitted it to the Salon,

he had decided to stand out against the tyranny of bad taste and to display his refusal to submit to official demands in no uncertain terms; *Olympia* represented his opposition to the cowardice of compromise. In the following year, Emile Zola, having admired the canvas once again, turned his cutting irony on to his readers: ' If only Manet had borrowed a powderpuff from Cabanel and had lightly powdered Olympia's cheeks and her breasts she would have been a bit more presentable '.

Olympia is sardonically expressionless and not particularly beautiful; the shape of her figure stands out extremely clearly, not only against the background (very dark brown walls) but also against the cream-coloured bedspread, with its border of flowers, and the crisp white sheets. Behind her stands a turbaned Negro maid, who, with her hand curving round the great bunch of flowers she is offering (in a perfect formal arrangement), affirms a life more ebullient and real than that of her impassive mistress. At the feet of this French ' Maja ', this distant relative of Titian's Venuses, there is a cat far blacker than even the wall or the servant, with felinity blazing from its eyes. The composition of this painting is of the utmost simplicity, with the main subject flattened against the wall, as if cut out and stuck on; the girl is not really painted from life, she is not a representation, but an idol suspended, completely immobile, in endless time and space. Manet has interpreted Olympia as a kind of goddess devoid of material nature, and has in effect reduced her to an abstract series of colours, daringly juxtaposed. Courbet criticized the flatness of this painting, saying it was like a playing card, and it is interesting to see this as an allusion to the Japanese cards which Manet must have been familiar with at this time.

The fact that at this period Manet's paintings were regarded as indecent and Courbet's work, also hanging in the Salon, as rather feeble gave heart to the opponents of realism. Tired of being more and more gravely misunderstood, Manet decided in August to go to Spain, following an itinerary planned for him by Astruc. He stayed only two weeks, but those two weeks were a tremendous experience.

The Spain that he had absorbed from paintings in Parisian galleries, and from the dance and theatre which were in

vogue in Paris, was ousted by direct, real experience which may have been less susceptible to romantic metaphor, but which was filled with burning sensation and authentic reaction, far removed from mere fashion. And from now on his interest in foreign customs, which had occupied such an important place in the paintings of the preceding years, gave way to a desire to convey, with increasing freshness and immediacy, the world he inhabited; this of course meant Paris, and he dreamed of doing for Paris what the Spanish painters had done for their country.

After his holiday in Spain he painted three pictures of bull-fights (Art Institute, Chicago; Matsukaka Collection, Tokyo; Goldsmith-Rothschild Collection, Paris) which are a passionate testimony to the intensity of his appreciation of this spectacle. His trip marked the conclusion of his Spanish period, as far as the choice of subjects was concerned, and in about 1865 his adherence to Velázquez ceased; but between 1865 and 1870 his relationship with Spanish culture appeared rather more subtly in his work through his first-hand knowledge of the painting of Goya. This appeared tentatively at first, but later with great force, so that at times Manet's Spanish flavour seems to be completely wrapped up in echoes of Goya, including some direct compositional appropriation.

Manet came back from Spain with a new friend, Théodore Duret, whom he had met in his hotel in Madrid. In Paris he abandoned the Café de Bada and Tortoni's terrace, and began to go regularly to the Café Guerbois, in the Avenue de Clichy; his personality and artistic temperament, and a growing admiration for his paintings, attracted numbers of intellectuals to him, and young painters began to think of him as their leader. On Thursday evenings at least two tables were reserved for his friends: Antonin Proust, Fantin-Latour, Bazille, Whistler, Nadar, Astruc, Duranty were regulars. Others who came included Renoir and A. Silvestre and, occasionally, Degas, Monet and Cézanne. These reunions were the beginning of a growing interest in Manet; his brilliant conversation and his fiery temperament exerted an extraordinary fascination over those who knew him. Clearly, also, the painters who met weekly like this were keen to understand one another and to establish a

working relationship between members of their group, later to be known as the impressionists. They saw in Manet a key figure in the development of their ideas, though eventually they all moved off in different directions.

The most notable paintings painted after Manet's trip to Spain are the *Tragic actor* (Vanderbilt collection, New York), which was certainly inspired by Velázquez, and the *Fifer* (*pl. 27*).

In the *Tragic actor*, as in many of Manet's paintings, the painter shows impressive perception and highly developed intuition, portraying things exactly as they are and curbing his imagination. In fact he does frequently turn to subjects which have already been used by other painters, sometimes his contemporaries, and re-works them with surprising fidelity. Yet he treats them with such freedom and originality that no obvious interpretation of the subject ever results from it: the meanings he attaches to the subject are always utterly unforeseen.

The *Fifer* is one of Manet's most famous paintings, and it is also one of his most daring works; here perhaps more than anywhere else can be found a synthesis of all that is most complex in his vocabulary. The young band boy of the Imperial Guard was painted with reference to Victorine Meurend (though she was not exactly Manet's model); his bright uniform is painted in only three colours, red, black and white, with decorations of dull gold, and is placed in contrast to a vague, indefinite background, lighter around the figure, darker at the edges; the background is not really firm enough to provide a platform to support the boy but his figure seems so solid that his steady stance alone provides him with a base. His fife is held to his lips in a perfectly natural gesture, and the crook of his right elbow, necessarily bent to support the fife, gives definition to the space behind him and is an essential part of his outline; his form, rather than being flattened out like a playing card, seems to create a double dimension, the first being the small figure of the boy, the second his eyes and the spectator's eyes meeting between the rather crudely painted eyelids.

This picture is of capital importance in the history of Manet's career; its style, which is irreproachable, tells the whole story of his experience and interests. Traces of Spanish and

Japanese art play their part in the final synthesis, in the plan, with its measured rhythm, and the swift, brilliant colour contrasts; the economy of Manet's style may have owed something (as Leymarie points out) to the art of photography at which he was a keen amateur.

Anyway, since Manet's story is partly a story of official fall-ure, it is necessary to note that both the *Tragic actor* and the *Fifer* were rejected at the Salon of 1866, and Manet set up an exhibition for his friends in his own studio. This was the year when Zola made his first visit to Manet's studio, introduced by Guillemet and Duranty. Zola looked at the recently rejected paintings and at other pictures painted previously, and detected a coherent progress in the painter's work. ' The place of M. Manet in the Louvre is assured ', he prophesied, ' as is that of Courbet and of any other artist of so original and powerful a temperament. '

Cézanne was also introduced to Manet during that year, and Manet promised to visit him in his studio; both painters had been turned down by the Salon. Monet's paintings, on the other hand, were not only accepted but were some of the most successful pictures of that year, with both the public and the critics. Zacharie Astruc made a great effort to introduce Monet to Manet, and Manet liked him at once, in spite of the annoyances caused him by the confusion of their two names. This was the moment when the definition of the term naturalism was under discussion; at the Salon of 1863 Castagnary had attempted to make people understand that the term realism was no longer suited to the spirit of the paintings of Manet, Monet and their friends, whose interest in romantic subjects and landscape and total lack of interest in social themes called for a new critical appellation. Zola welcomed Castagnary's ideas, but the painters themselves took very little notice of the dispute and continued to paint in their separate ways.

At the Salon of 1867 Manet appeared only as a sitter in a group portrait by Fantin-Latour; as a reaction against persistent rebuffs he had built, on the advice of Courbet, a wooden exhibition booth in the Place d'Alma. But even though this exhibition and the Courbet exhibition directly opposite created a good deal of interest, the critics, even the friendly ones, were lukewarm in their praises, and the

public once again poured scorn on the paintings. Manet had painted a picture expressly for this exhibition which for political reasons he was prohibited from showing. The subject had been suggested to him by a dramatic event in the Mexican revolution. Although he generally stood well back from historical or social subjects he was interested in contemporary affairs, and especially those which appealed to his liberal soul; the fate of Napoleon III's protégé Maximilian impressed him so greatly that he painted a first version of the *Execution of Emperor Maximilian* in June and July, and later painted two more versions, cutting up the more elaborate of the two into a sketch and a lithograph. The version which expresses the artist's intention most clearly is the one in Mannheim (*pl. 32*); here the event is seen on an anti-heroic scale quite antithetical to the normal image of the tragic emperor of Mexico.

Manet spent the summer at Boulogne and Trouville and hurried back to Paris on 3 September for Baudelaire's funeral. Their friendship had not been a very long-standing one, but was still important, particularly for Manet who had had encouraging reviews from Baudelaire and had been introduced by him to Spanish themes. Baudelaire had also spoken comfortingly to him at his moments of near despair, when success seemed to have escaped him irrevocably. He wrote in a letter of 1865: ' Do you imagine that you are the first person to be in this position? Are you more of a genius than Chateaubriand or Wagner? ' (Though he added ' You are the first only in the decrepitude of your art '.) But any reserve Baudelaire felt in his appreciation of certain aspects of Manet's painting was offset by his tremendous admiration for him.

The friendship and esteem shared by Manet and Zola is complex, if less difficult to understand. Zola was a regular frequenter of the Café Guerbois and in 1866-7 he had been extremely generous with praise and flattering remarks about Manet. ' The term realist means nothing to me ', said Zola. ' Paint honestly and I applaud; but paint individualistically and in a lifelike way and I applaud much harder. ' His intention was to draw the painter's attention to the power of his own individual expression, so that realism would be the outcome of naturalism. With this in mind he applied

himself to the comprehension of Manet, seeking to understand his private vocabulary and the personal, unique significance of his paintings.

The discussions at the Café Guerbois must have circled around such ideas, and also around the ideas put forward by the young impressionists which were only partly shared by Manet. Manet, to show his gratitude for Zola's friendship and support, painted his portrait (1868, *pls 33-4*) and this and the *Woman with parrot* (*pl. 26*), painted two years earlier, were accepted at the Salon of 1868. The *Portrait of Emile Zola*, now in the Louvre, is more than just a record of a friendship; this is one of Manet's most elegantly constructed paintings, and it is also a precious testimony to the culture of the period. Both the writer and the painter and his friends of the Groupe de Batignolles were at the very core of artistic and literary Paris in the second half of the nineteenth century; and in this portrait Manet put various references which allude to the interests of these people at the period when it was painted. The picture is modelled with the flat, very basic kind of relief which Manet used in many of his best paintings so that each object is stated with brilliant clarity, but none projects more than another. The amber-coloured head is silhouetted against a dark background, the white pages of the book against the jacket, the right hand in delicate contrast to the black desk. On the top of the desk the objects lie about as if they had just been moved; they are painted in a few carefully harmonized colours and disposed in a casual disorder in which each plays an indispensable part, as they must have to Zola when he used them. The Japanese print and the screen may have been bought at 'Porte Chinoise', opened by Madame Soye in the Rue de Rivoli in 1862, which become very popular amongst artists. The painting by Velázquez bears witness to Manet's preference for Spanish painting and the photograph of *Olympia* reminds us that this controversial picture remained Manet's favourite, and that it had brought him and Zola together in the first place.

In the summer of 1868 Manet returned to Boulogne, to rest and to work. The sea was beginning to interest him, and during this season it was to appear more and more frequently in his notes, drawings and paintings. The hot

summer of 1868 is memorable above all for one painting, one of the most serene and complex works done during those years, *Luncheon in the studio* (*pls 37-9*). The central axis of this picture is the young man in the foreground, painted right in the front in a pose suggesting suspended animation; his body is divided into bands of light and dark colours, through his trousers, his jacket and his head. His position determines the placing of the other two figures, on the right a man placidly meditating, on the left a woman standing in a wonderfully delicate network of neutral shades, strongly reminiscent of Chardin. Her relationship with the furniture and the pieces of household equipment is unstable; the shadow of the rubber-plant cuts across her face; the silver coffee-pot sets off the black of Léon's coat, and the silhouette of the cat traces elegant flourishes against her dress, which itself seems lit by reflections from the shining coffee-pot and the curious heap of armour and weapons. On the tablecloth the objects immediately impress one as being alive, steeped in the presence of humanity (*pl. 37*). Manet's still-lifes always have this quality of life, which eludes definition and even scrutiny, as it exists entirely in the mind; the objects here are chromatically in a most delicately balanced relationship, and they express to the full the sensual delight which Manet derived from matters of detail.

Berthe Morisot came into Manet's life in the winter of 1868. He had admired her *View of Paris* at the Salon the year before, and he certainly had it in mind (as well as Goya's *The Field of San Isidro*) when he painted the *View of the Universal Exhibition in Paris*, now in the National-galleriet, Oslo; this is a snippet of *vie parisienne*, with detail hastily filled in and colours fading away to the background. Fantin-Latour introduced Berthe to Manet and he was struck by her charm as well as by her ability as a painter; he asked her to pose for him and she, obviously won by his dashing manner, began to appear regularly in his studio (accompanied by her mother) until 1874, the year of her marriage to Eugène Manet. During this period Manet painted some of his most appealing feminine portraits; besides beauty and feminine charm he infuses them with a kind of enchantment, drawing the spectator into a

magic circle and communicating to him an acuteness of feminine intuition, which he himself in large part possessed. The arrangement of colours in these portraits is delicate and tender, most true to life. In 1868 the first work for which Berthe Morisot was asked to pose was *The Balcony* (*pls 41-42*), accepted by the Salon of 1869. This was partly inspired by Goya's *Majas on a balcony*; he may have had the same painting in the back of his mind as early as 1865 when he painted *Angélina* (*pl. 25*), now in the Louvre. The stimulus of seen reality definitely coincides here with memories of Goya.

This participation in the Salon did not represent any real success for Manet; *Luncheon in the studio*, shown at this time, was the work of an innovator, but the same cannot be said for *The Balcony*. Mlle Morisot sits in the front, painted with the brilliance and fervour of a Goya: black helmet of hair, shining eyes, opulent silken clothes. But the other figures, standing back in the shadows, are far less distinguished. Guillemet looks pompous and stupid, Jenny Clauss a stereotype, and the painting as a whole seems to suffer from the uneven distribution of the figures.

In the summer of 1869 Manet was in Boulogne again. Castagnary had recently criticized his painting of imaginary subjects; stimulated both by this and by his discussions in the Café Guerbois about painting impressions from life at speed, to keep them spontaneous and fresh, Manet decided to paint scenes and landscapes which surrounded him: the beach, bathers and the busy harbour. The *Departure of the Folkestone boat* (Philadelphia, Tyson collection) is an example of his observation of a daily event, painted out of doors, from life. His attempt to reconcile his usual attitude to reality with direct observation (though this resulted in discords and contradictions at times) led Manet towards an understanding of those painters whose hopes he shared, if not their ideals and their aims. The paintings in the Salon of 1869, *Portrait of Eva Gonzalès* and *Music lesson*, only gave a slight indication of Manet's new interests; although the *Portrait of Eva Gonzalès* has a kind of bold, positive appeal the *Music lesson* consists of certain curiously disparate elements brought together by the luminous atmosphere which enfolds them all.

On 18 July France declared war on Prussia, and on 2 September the defeat of Sedan brought the collapse of Napoleon III. When the Third Republic was proclaimed Manet, who had always (discreetly) manifested republican leanings, sent his family to the South of France and enlisted in the artillery. The Siege of Paris did not realize Manet's hopes of having time to make a few studies from nature. The surrender of the capital took place at the end of January, and it was not until 12 February 1871 that Manet was able to go down to Oloron Sainte-Marie to see his family. He stayed there and in Bordeaux and Arcachon until the end of May, whilst Paris was suffering the excesses of the Commune. When he returned to Paris in the last revolutionary days there was still some fighting going on in the streets, on the barricades, and Manet made some drawings and two excellent lithographs.

In the course of the summer he left again for Boulogne. During his months away from the capital Manet's interest in sea-side landscape, particularly in the harbour at Bordeaux, had been revived; now in Boulogne he pursued his new themes with tremendous fervour. This period certainly witnessed an important departure from the course Manet had hitherto pursued: even if he had not always agreed with Monet, Renoir and Pissarro in his discussions with them, he was nevertheless interested in experiments very similar to theirs, and without making any radical change in his style he conceded that superficial effects should mirror the basic mutability of the atmosphere. The *Harbour at Bordeaux* (1871) testifies to his new interests: the shapes are very forcefully separated from one another, the foreground and the background being in places painted in a completely contradictory manner, yet the light is so beautifully handled that it allows any infelicities to be glossed over.

Manet had begun painting in the open air in 1866, completing the whole picture out of doors to preserve the stylistic unity throughout, and he had spoken of this method to his friends with confidence and enthusiasm. A foretaste of this is discernible in the *Races at Longchamp* (*pl. 23*) in which he attempted to capture the sense of speed which the ever-changing light and the random distribution of light and dark

forms provide. Meanwhile the Salon of 1872 accepted *Alabama and Kearsarge*, painted in 1864 and already in the possession of Durand-Ruel. Durand-Ruel, a dealer, had returned to France after the war and had begun to take an interest in certain young painters, who discovered in him not only a collector, but also a friend and supporter. In the winter of 1871-2 he saw two pictures by Manet in Steven's studio; he bought them both, and a few days later he visited the painter's own studio and purchased the twenty-three paintings that he found there for a total price of 35,000 francs. Manet then retrieved other paintings from friends to whom he had lent them, and Durand-Ruel returned and bought some more, including *Music in the Tuileries*, which was hung with ten other paintings of Manet's in an exhibition of French painting organized by Durand-Ruel in London.

The fact that he had sold such a large number of paintings to Durand-Ruel, and the financial help he had received from the sale, gave Manet a certain amount of security and confidence; he hoped that his painting would at last be appreciated widely by the public and by certain areas of critical opinion as well. Subsequent events seemed to confirm what he had hoped. The Salon of 1873 had accepted *Repose*, painted in 1869 (*pl. 44*), a portrait of Berthe Morisot sitting on a sofa, dressed in white watered silk, firmly outlined with strong strokes of the brush, yet subtle and delicate at the same time; also *Le Bon Bock* (Tyson collection, Philadelphia), painted at the beginning of 1873. The success that the painter had longed for, not always privately, came to him from a painting which displayed an offhand, almost scornful virtuosity, a marvellous aptitude for characterization and a discursive freedom in the use of colour, borrowed here from Frans Hals whose paintings he had been studying in Haarlem. The figure of the engraver Bellot, good-naturedly sitting in the Café Guerbois, with its intense patches of colour, appealed to everybody, except to Manet's friends, or rather to those who knew him best. These few were becoming convinced that too much compromise was necessary to be accepted at the Salon, and they were now toying with the idea of exhibiting on their own. They hoped that Manet would join them; the economic crisis and

the difficulty of selling paintings by young painters was discouraging Durand-Ruel from making any further purchases. It was vital now to make a decision which would bring the Groupe de Batignolles to the public notice; it was quite possible that exhibiting with them might confer greater prestige than the Salon, since the Salon would only accept three paintings each year at the most. Manet was extremely doubtful, not only about the participation of Cézanne in the group, but also because he was still confident of the efficacy, from the point of view of prestige, of showing at the Salon; he declined to take part in the initiative and Degas remarked 'Manet seems determined to stand apart; he may well live to regret it.'

From July to September of that year Manet was at Breck-sur-Mer; the paintings and watercolours he did were all painted out of of doors, and were a kind of rejoinder to the preoccupations of the impressionists. His success, though short-lived, had given him the desire to take stock of himself and the resulting feeling of liberty and serenity gave him an opportunity to work conscientiously at his figures and at the light which surrounded them. In the landscapes of this period the way the colours are fused with the light testifies to his efforts, and the results are similar in some ways to those achieved by his colleagues at Batignolles; but the difficulties and setbacks he experienced can be found, too, in other paintings of the period.

In *Gare Saint-Lazare* (*pls 51-52*) Manet used the same model as he had used in *Olympia*. But time had wrought changes in his painting far more drastic than those wrought on the mature beauty of the lady sitting by a small girl against the iron railings of the station. The figures appear, as an American critic has observed, as if they had been clipped out of a sheet of tin; this is because Manet had been searching for a new kind of colouring against which objects would stand out sharply in relief: the cloud of steam which attracts the attention of the girl. He achieved a more coherent painting in *Croquet match* (Staedelsches Institut, Frankfurt), where the warm light, filtering through the trees, fills the lawn with patches of reflected light and illumines the figures, without depriving them of their poetic formality. *On the beach* (*pl. 47*) is another very coherent painting, the

isolated figures in the foreground achieving a marvellous sense of communication with the distant sand and sea.

Manet had only just returned to Paris when, in October 1873, a fire gutted the Opéra. He rushed to the scene to record the disaster in his sketchbook. He had taken up painting pictures of society again in the *Masked ball at the Opéra* (Havemeyer collection, New York), and here the feeling is not dissimilar to the feeling that had once suggested to him *Music in the Tuileries*; in the new painting the colours are richer and it is dominated by the burnished effect and glinting reflections given by artificial light. This everyday episode, so familiar to his eyes, is transformed into a fairy story.

On 15 April, on the premises of Nadar, the photographer, the exhibition of the 'Sociéte anonyme des artistes peintres, sculpteurs, graveurs etc.' opened; after ten days it was to be named the 'Exposition des Impressionistes' by Leroy, art critic of *Charivari*. Once again a critic, American this time, confused the name Manet with Monet and jokingly referred to the painting in the Salon (*Gare Saint-Lazare*) and those (by Monet) in the 'exceedingly comical exhibition' as ridiculous daubs. An epigram laid all the blame on Manet: although he was the enemy of impressionism, he had after all been one of the prime movers of the artistic schism. There was only a grain of truth in this; Manet had adopted a few of the principles of his impressionist friends, but he was in fact so far removed from their style that if his paintings had been hung beside theirs the difference would have been noticeable to all; his relationship with the group was clear – he was interested but completely independent. It is true however that with his painting, at any rate until 1870, he had been instrumental in bringing about the schism with official art, abstracting himself before any of the others from the tyranny of the subject and preparing the way, by preparing critical and public opinion, for the new kind of painting. For the impressionists he was what Courbet had been in his own eyes; he represented a precedent for innovation to which they could appeal.

That summer he spent at Gennevilliers, near Argenteuil, where he had also rented a house for Monet, in serious financial difficulties at the time; he spent a lot of his time

with him and with Renoir, and they all worked together. During those months he was more than ever interested in *plein air* painting, and in the paintings of Monet. From this admiration and understanding came the picture called *The Monet family in the garden at Argenteuil*, in which Camille's dress stands out like a brilliant flower against the green shadows. Claude and Camille appear again in the painting of *Monet painting in his studio boat* (*pls 55-6*); Monet's presence is felt here chiefly through the strength of the influence he was exercising on Manet at that time. Manet, however, does not break down his colours prismatically but uses very bright, small brushstrokes; he prevents objects melting away into the background by giving them a strong chromatic presence against the gentle, fluid landscape behind. *Argenteuil* (*pl. 54*), painted during this summer, shows two people sitting in a boat with the small port in the background; the stolid stillness of the couple contrasts with the light, rapid painting of the colour and lights on the water. *In the boat* is perhaps the best of all the paintings of this period; the boat is seen from a peculiar angle, gliding from the left to the right of the canvas, and this conveys the sense of the transience of the moment perfectly, giving the painting a kind of timelessness.

Manet sent only one picture to the Salon of 1875, as he was afraid of being turned down; *Argenteuil* was accepted but once again it was the butt of violent criticism. During the same summer, after the publication of Edgar Allen Poe's *The Raven*, translated by Mallarmé with wood engravings by Manet, Manet was the guest of the collector Hoschedé at Montgeron; staying in such surroundings must have crystallized his long-felt ambition to be hailed as a success and to be accepted into the kind of society which he felt really suited him, whose recognition and acclaim he longed for. In September he spent some time in Venice and came home with two paintings.

Now that he had tasted a certain amount of success, though he continued to frequent Monet and his friends, helping them when the occasion presented itself, he was still trying to win support and backing from influential people who might have been able to assure his annual acceptance at the Salon, and finally to obtain for him the little red ribbon of

the Légion d'honneur, which Degas regarded with such biting irony. Meanwhile he again declined an invitation to take part in the second impressionist exhibition, and the Salon refused *The linen* and *The artist*. The first was a painting in which Manet demonstrated his continued allegiance to the ideas of Monet: the sun beating down on the clothes breaks the light into tiny particles and bathes the whole picture in a warm, liquid atmosphere. In *The artist* (*pl. 57*), a portrait of Desboutin, a painter who was willing to join Monet's group for the second show, there is a slightly Bohemian flavour, in spite of the straightforwardness and energy of the composition.

At the Salon of 1877 one of the paintings submitted by Manet was accepted, the *Portrait of Faure as Hamlet*, but the other, *Nana* (*pl. 62*), was refused, obviously for reasons of propriety. Gay Paris would probably have felt uneasy in front of the graceful silhouette of the *cocotte* who bore the same name as the novel by Zola: she is captivated by the reflection of her face in the glass, but every movement is followed hungrily by her well-dressed admirer. On the wall is a silk hanging decorated with leaves and a flamingo. *Nana* may not have quite the stature of *Olympia*, but the brilliant, rapid brushstrokes bring out the compact shape of her body and her arched back: this is a piece of social history, daring and up-to-date.

Manet had at this time in his studio other paintings to match the one that had been refused, paintings in which his pictorial vein, though dispersed over a wide variety of subjects, achieves its most intense and immediate expression, capturing all the gaiety and transience of the world. Some of his finest paintings date from this period: for instance *The plum* (Arthur Sachs collection, New York) and *Skating* (Wertheim collection, New York), in which the motif is seized at its most fleeting moment with the utmost lightness of touch.

The Café Guerbois had now been abandoned in favour of the Café de la Nouvelle-Athènes in the Place Pigalle, and here Manet found himself amongst old and new friends. Desboutin, Degas, Renoir, Rafaelli, Zandomeneghi, the engraver Guérard, who married Eva Gonzalès in 1878, and also Victorine Meurend, Manet's model, who in 1876 had

had a self-portrait hung in the Salon. Often enough Manet would take up his pencil and make rapid sketches of the café and its customers, and portraits of his friends, including a particularly interesting series of portraits of the Irish writer, George Moore.

But two events had taken place which were seriously to affect the circumstances of Manet and his friends. In April 1878, Faure, the actor, who had often bought his paintings, auctioned nearly half his collection in the expectation of a considerable profit. Even more disastrous were the prices reached in the enforced sale of his paintings by the creditors of the banker Hoschedé. The impressionists now found themselves in an appalling position, and Manet was by no means well-off himself, though he was trying to eke out his friends' minuscule resources. Rejected by the Salon of 1878 and barred from the artistic section of the Exposition Universelle, he had thought of having another private exhibition in his studio, but he gave up that idea. That summer he prepared to leave his studio in the Rue de Saint-Pétersbourg for new premises at 77, Rue d'Amsterdam; before he left he painted the view from his window as a lasting reminder of his old studio. The five views of the Rue Mosnier are some of the most vivid of Manet's impressionistic paintings, certainly of those painted in the town. He surrenders completely to the exciting way the light plays on the walls of the houses, using the street as his entire subject, without omitting any of his favourite details such as the flags, with their gaudy stripes (*pl. 65*). In another of these views the dark blobs of the carriages bouncing about on the cobbles are like exclamation marks in an otherwise coherent, almost flat painting, and they accentuate by antithesis the subtlety with which light effects are handled. Also painted in 1878, *In the conservatory* (*pl. 69*) shows M. and Mme Guillemet painted by natural light, augmented by reflection from the glass which completely surrounds them. The *Self-portrait* (Goldschmidt collection, New York) is a rapid sketch, but a most revealing and gently ironical one. The Salon of 1879 accepted two of Manet's paintings, but in the spring of that year he had dreamed up his most ambitious project to date. He had written to the Prefect of the Seine Department and also to the Conseil Municipal

de Paris with the suggestion that he should contribute a series of paintings to the new Hôtel de Ville which would portray Paris from every aspect. The views of the city would have been divided up into Paris-Halles, Paris-Railway, Paris-Port, Paris-Underground, Paris-Racecourses and Paris-Parks. But this suggestion caused not the slightest reaction: Manet had hoped that his work would stand as a memorial to his time and to his beloved Paris; he planned a rather naturalistic series, inspired a little by Zola, which would be organized so that it would present a sort of pictorial epic of the town. Meanwhile he was spending plenty of time at the café-concert and in the brasseries; he was drawing and painting with that speed which captures the humour of the model, the flavour of the atmosphere, the gaiety of life and its precious transience, and all the feeling of contemporary society. The *Waitress* (*pl. 67*) was painted when he was a regular customer at the Reichshoffen beer cellar: the compact group of drinkers in the foreground is held together by the placing of the sources of light, by the brilliance of white against black, ' that black which is Manet's own ', as Valéry described it; he uses black as a colour and it vibrates as a colour does. The figures in the tight enclosure of the group seem to move within a circle, they seem to live and breathe. They stand out vividly against the light background.

In 1879, whilst Monet and his friends were planning their fourth joint exhibition, Manet decided to make his work known in the United States, and showed *The Execution of Emperor Maximilian* (*pl. 32*) in New York. The critics were moderately enthusiastic, and a few painters took an interest, but hardly any of the general public came to look, and after an even less successful exhibition in Boston Manet decided to cancel his show in Chicago, planned for the first months of 1880. He exhibited in Paris, at Charpentier's *La Vie moderne*, and sent the conventional *Portrait of Antonin Proust* (Toledo, Ohio, Museum of Art) to the Salon, with *Chez le Père Lathuille* (*pl. 70*). These had a considerable success and the possibility of a decoration was even discussed. In 1879 Manet had begun to notice the symptoms of ataxia, and since it interfered with his movements and made it difficult to hold a brush and manipulate paint

with his accustomed ease, he began to resort more and more to pencil and pastels, which are easier to handle. All the beautiful ladies of Paris were before his eyes, and the pastel chalks, with their softness and the gentleness of their colours, gave his pictures a marvellous new lightness and an almost unexpected beauty; the women are accurately analysed, and yet they are exalted. In the summer Manet rented a house in the country at Bellevue, near Paris; but he complained to Astruc that the country only charms those who are not forced to stay there. He wrote asking his friends to comfort his isolation by visiting him, and his letters were decorated with graceful watercolour sketches.

In October he returned to Paris, and although his illness had not responded to treatment he took up his old life in cafés and brasseries with renewed energy; his mother and his wife opened their salon to artistic and political personalities. Clémenceau was a regular visitor, and Manet painted two slightly unconvincing portraits of him (*pl. 72*); Mallarmé used to come, and Chabrier who had shared Manet's passion for Spain. Manet enjoyed these meetings and took a lively part in the discussions that were held on topics of the day; he now painted the *Escape of Henri Rochefort from New Caledonia*, and when Rochefort's sentence had been quashed he painted his portrait and sent it to the Salon of 1881; to accompany it he sent a portrait of the famous lion-hunter, Perthuiset. For these he was awarded a second-class medal, but this was strongly disapproved by his opponents. That summer he was in the country again, in a villa at Versailles. This was the period at which he painted some of the freshest, most spontaneous landscapes of his last years. The countryside is immersed in a warm glow, the colours are dazzling, the brushstrokes rapid and accurate; Manet seems to have arrived at such a vital love of nature that he can make the most commonplace object appear of infinite distinction and importance. The following summer the house and garden at Rueil inspired more marvellous country paintings, which express his love of looking at things and of analysing their inmost secrets in light and brilliant colour.

When he returned to Paris in the autumn of 1881 he learned that Proust had put his name forward to Gambetta for

the Légion d'honneur. After so many years of struggle and frustrated hopes, Manet was going to achieve his red ribbon only just in time. Renoir, writing from Capri to congratulate him on his official recognition, conveyed an affectionate and accurate pen-portrait: 'You are the joyful fighter, hating nobody, like an ancient Gaul; and I love you for your gaiety even in the face of injustice.'

At the Salon of 1882 Manet exhibited *hors concours*. He submitted *Spring* (Payne Bingham Collection, New York), a symbol of eternal youth, one of the four portraits of women which were to represent the four seasons: he had already painted *Autumn* (Musée des Beaux-Arts, Nancy), in the person of his friend Mary Laurent; also *A Bar at the Folies-Bergère* (*pls 77-8*), a subject he loved and repeated often; he had painted this one a few months beforehand. The public judged it entirely by its subject, which they considered banal. Tired and sick, Manet had dragged himself once again to the Café des Folies-Bergère, and in the midst of the dazzling women and the bright lights he had courageously set out to record one last sparkling scene before his death. Behind the bar Suzon, the barmaid, who had also posed for delicate pastel portraits, is talking to a client as the mirror behind reveals, and we can also see the dense crowd of customers sitting in the café, and the brilliant chandeliers above. In the foreground the girl seems to have withdrawn into herself for a moment: the look of concentration on her soft pink and white face, her bodice with its elegant lace and flowers echo Manet's exaltation of life.

In the summer at Rueil he painted watercolours and pastels, some portraits and some flowers. But in Paris that winter he spent longer and longer periods in bed and his friends began to be seriously worried about him. On 1 April his doctors, alarmed by the appearance of gangrene, decided to operate and did so, but unsuccessfully. When he died, on 30 April 1883, he left unfinished the *Portrait of Elisa* which he had been working on since March. His last words were words of bitter regret for the hostility which his work had aroused, which had always been a torment to him.

From 1859 to 1883 the story of Manet's life is intimately bound to the history of the Salons, and at the same time

to the progress of modern painting. He was able to use the background of realism, interpreting it in his own way, tempering it with selections from other cultures past and present, and at the same time he was able to point the way to other artists, to the impressionists in particular, towards a new freedom of choice, outside the limits of mere representation, especially in the field of colour; Manet's simplification of forms gave his subjects an immediate freshness and spontaneity.

When, at the close of his last Salon, Manet had received his Légion d'honneur, he could not refrain from replying to the people who came to congratulate him that it was already too late to make amends for twenty years of failure. A few days later, embittered by the reception accorded to *A Bar at the Folies-Bergère*, he wrote to the critic Wolff with mournful irony: ' I should be fascinated to read while I am still alive the stunning article that you are going to write about me after my death.' This was an accurate prophecy, though it did not come true immediately; for a while Manet's name was obscured by embarrassment and misunderstanding. But his words were a true assessment of the position of his own painting in the history of modern art.

Manet and the Critics

The earliest references to Manet can be found in the writings of his friends. His relationship with Charles Baudelaire probably began some time before 1860, and Baudelaire's remarks about him are generally to be found in letters to friends or to Manet himself. Later Baudelaire was inspired by the tragic death of a boy who had been Manet's model for some time (he appears in *Boy with cherries, pl. 1*), and based a short story on the tale, *La corde*, which was included in the collection called *Le spleen de Paris* and dedicated to Manet. He also wrote the memorable quatrain for Lola de Valence, and his criticisms of Manet's painting can be found condensed in ' Peintres et aquafortistes ' in *Réflexions sur mes contemporains.*

As Roberto Longhi remarks in his introduction to the Italian version of John Rewald's *History of Impressionism* (Sansoni, Florence 1949), which is a text of the utmost importance for the study of Impressionism, one of the earliest examples of unsolicited interest in Manet's work was provided by an Italian woman, Giulia Ramalli, who lived at Versailles and who, after the signal failure of *Olympia*, wrote to Manet to ask the price of the painting.

Manet's friendship with Zola can be dated more or less from the appearance of *Olympia*; Zola published a study of Manet in 1867, in Paris: *Edouard Manet, étude biographique et critique*, and a later study which concentrated more on his qualities as a painter in ' Mon salon ', in *L'événement illustré* of 2 May and 16 June 1868; the main character of Zola's novel *L'Oeuvre* (Paris, 1886), though fundamentally based on Cézanne, shares certain temperamental characteristics with Manet. He also bears common characteristics with another hero of a novel, the painter in Philippe Burty's *Grave imprudence* (Paris 1880); he is portrayed in George Moore's *Confessions of a young man* (London 1888).

Accounts of the Salons, critical writings and articles by G. Rivière, Théodore Duret, Zola, A. Silvestre, Duranty, Théodore Burty, Castagnary, Gautier, Z. Astruc, and Camille Le-

monnier all contain references to Manet, as documented in Venturi's *Les archives de l'Impressionisme* (Durand-Ruel, Paris and New York, 1939).

The first important criticisms of Manet's painting to appear in Italy were those of Diego Martelli, reprinted in *Scritti d'arte* edited by A. Boschetto, Sansoni, Florence 1952. Anthologies of Manet's letters have been compiled by Duret, Tabarant and Guiffrey.

Finally, here is a short bibliography of works devoted to Manet: E. Bazire, *Manet*, Paris 1883 (the first biography, written the year after his death); Théodore Duret, *Histoire d'Edouard Manet et de son oeuvre*, Paris 1902; E. Moreau-Nélaton, *Manet raconté par lui-même*, two vols., Paris 1926; P. Jamot, 'Manet as a portrait painter', in *Burlington Magazine*, XLIX, London 1926; P. Jamot, 'Manet peintre de marines et autres études', in *Gazette des Beaux-Arts*, LXIX, Paris 1927; L. Venturi, 'Manet', in *Arte*, XXXII, 1929; H. Focillon, *Maîtres de l'estampe*, Paris 1930; P. Jamot, G. Wildenstein, M. L. Bataille, *Manet*, Paris 1932, two vols. (catalogue and notes to 546 paintings); P. Valéry, *Le triomphe de Manet* (preface to the catalogue of the retrospective exhibition of Manet's paintings in the Musée de l'Orangerie), Paris 1932; R. Rey, *Choix de 65 dessins de Manet*, Paris 1932; R. Lambert, 'Manet et l'Espagne', in *Gazette des Beaux-Arts*, LXXV, 1933; G. Jedlicka, *Manet*, Zurich 1941; H. Graber, *Edouard Manet*, Basle 1941; M. Guérin, *L'Oeuvre gravé de Manet*, Paris 1944; I. N. Ebin, 'Manet et Zola', in *Gazette des Beaux-Arts*, LXXXVII, 1945; J. Rewald, *Edouard Manet, Pastels*, Oxford 1947; A. Tabarant, *Manet et ses oeuvres*, Paris 1947; J. Alazard, *Manet*, Lausanne 1948; D. Cooper, *Manet*, London 1949; J. Leymarie, *Edouard Manet*, Paris 1951; G. H. Hamilton, *Manet and his critics*, New Haven and London 1954; N. G. Sandblad, *Manet*, Lund 1954; G. Bataille, *Manet*, Geneva 1955; K. Martin, *Edouard Manet*, Basle 1958; J. Mathey, *Graphisme de Manet*, Paris 1961; P. Courthion, *Edouard Manet*, London and New York 1962; *Catalogue* of the Manet exhibition in the United States of America (195 works, New York, Philadelphia, Chicago), 1966-7; F. Neugass, 'Manet', (review of the exhibition in the United States), in *Weltkunst*, anno XXXVII, no. 2, 15 January 1967.

Notes on the Plates

1 Boy with cherries, 1858-9. 65×55 cm. Lisbon, C. S. Gulbenkian collection.

2 The Guitarist, 1860. 146×144 cm. New York, Metropolitan Museum of Art.

3 Manet's parents, 1860. 110×90 cm. Paris, collection of Mme J. Manet-Rouart. Manet kept this portrait of his parents until he died.

4 Boy with sword, c. 1860. 153×75 cm. New York, Metropolitan Museum of Art.

5-7 Music in the Tuileries, c. 1861. 76×119 cm. London, National Gallery.

8 Lola de Valence, 1862. 123×92 cm. Paris, Louvre.

9 Spanish Ballet, 1862. 61×91 cm. Signed and dated. Washington, Philips Memorial Gallery.

10-12 Luncheon on the grass, 1863. 214×270 cm. Paris, Louvre. This was inspired by the *Pastoral Concert* attributed to Giorgione.

13-15 Olympia, 1863. 150×190 cm. Paris, Louvre.

16 The Dead Christ with angels, 1864. 32×27 cm. Paris, Louvre. Sketch.

17 The Dead Christ with angels, 1864. 175×155 cm. New York, Metropolitan Museum of Art.

18-19 The Dead Toreador, c. 1864. 75×153 cm. Washington, D.C., National Gallery.

20 Still-life with carp, 1864. 73×92 cm. Chicago, Art Institute.

21 White peonies, c. 1864. 30×46 cm. Paris, Louvre.

22-3 The Races at Longchamp, 1864. 43×83 cm. Chicago, Art Institute.

24 Peonies in a vase, c. 1865. 91×69 cm. Paris, Louvre.

25 Angélina, c. 1865. 92×72 cm. Paris, Louvre.

26 Woman with parrot, 1866. 185×132 cm. New York, Metropolitan Museum of Art.

27 Fifer, 1866. 160×97 cm. Paris, Louvre.

28 Mme Manet at the piano, c. 1867. 39×46 cm. Paris, Louvre.

29 Soap bubbles, c. 1867. 100×82 cm. Lisbon, C. S. Gulbenkian collection.

30-1 Still-life, c. 1867. 45×71 cm. Paris, Louvre.

32 The Execution of Emperor Maximilian, 1867. 252×305 cm. Mannheim, Städtische Kunsthalle.

33-4 Portrait of Emile Zola, 1868. 190×110 cm. Paris, Louvre.

35-6 Reading, c. 1869. 61×74 cm. Paris Louvre.

37-9 Luncheon in the studio, c. 1868. 120×152 cm. Munich, Bayerische Staatsgemäldesammlungen.

40 Portrait of Théodore Duret, 1868. 43×35 cm. Paris, Petit Palais.

41-2 The Balcony, 1868-9. 169×123 cm. Paris, Louvre.

43 Moonlight, harbour at Boulogne, 1869. 82×101 cm. Paris, Louvre.

44 Repose, 1869. 155×112 cm. Providence, R. I., Museum of Art.

45 Eva Gonzalès, 1870. 181×135 cm. London, National Gallery.

46 Berthe Morisot with a bunch of violets, 1872. 55×38 cm. Paris, Rouart collection.

47 On the beach, 1873. 57×72 cm. Paris, Louvre.

48-9 Lady with fans, 1873-4. 113×168 cm. Paris, Louvre. The lady is Nina de Callias.

50 Lady with fan, 1872. 58×43 cm. Paris, Louvre. This is a portrait of Berthe Morisot.

51-2 Gare Saint-Lazare, 1873. 93×112 cm. Washington, D. C., National Gallery.

53 Mme Manet on a blue sofa, 1874. Pastel, 49×60 cm. Paris, Louvre.

54 Argenteuil, 1874. 149×131 cm. Tournai, Belgium, Musée des Beaux-Arts.

55-6 Monet painting in his studio boat, 1874. 81×100 cm. Munich, Bayerische Staatsgemäldesammlungen.

57 The artist, 1875. 193×130 cm. São Paulo, Brazil, Museu de Arte.

58 Woman on horseback, 1875-6. 90×116 cm. São Paulo, Brazil, Museu de Arte.

59-60 Portrait of Stéphane Mallarmé, 1876. 26×34 cm. Louvre, Paris.

61 Woman with gold brooch, 1877. 91×71 cm. Formerly in Paris, Pellerin collection.

62 Nana, 1877. 150×116 cm. Hamburg, Hamburger Kunsthalle.

63 Blonde with bare breasts, 1875-8. 60×49 cm. Paris, Louvre.

64 Singer at café-concert, c. 1878. 93×74 cm. Paris, Rouart collection.

65 Rue Mosnier decorated with flags, 1878. 65×81 cm. Formerly in the Jakob Goldschmidt collection.

66 Café-concert, 1878. 46×38 cm. Baltimore, Md., Walters Art Gallery.

67 Waitress, 1878. 98×79 cm. Paris, Louvre.

68 Mlle Gauthier-Lathuille, 1879. 61×50 cm. Lyons, Musée.

69 In the conservatory, 1878. 115×150 cm. Berlin, Nationalgalerie. The couple are M. and Mme Guillemet.

70 Chez le Père Lathuille, 1879. 92×112 cm. Tournai, Belgium, Musée des Beaux-Arts.

71 Portrait of George Moore, 1879. 55×35 cm. New York, Metropolitan Museum of Art.

72 Portrait of Georges Clemenceau, 1879-80. 94×74 cm. Paris, Louvre.

73 Portrait of a woman, 1880. 53×44 cm. Paris, Louvre.

74 Asparagus, 1880. 16×21 cm. Paris, Louvre.

75 Mme Guillemet in décolleté, 1881. 55×45 cm. Vienna, Kunsthistorisches Museum.

76 Study for 'A Bar at the Folies-Bergère', 1881. 54×34 cm. Dijon, Musée des Beaux-Arts.

77-8 A Bar at the Folies-Bergère, 1881-2. 96×130 cm. London, Courtauld Institute Galleries.

79 Horsewoman, 1882. 74×52 cm. Berne, Koerfer collection.

80 Mary Laurent, 1882. 56×46 cm. Dijon, Musée des Beaux-Arts.

81 A Corner of the garden at Rueil, 1882. 82×66 cm. Berne, Kunstmuseum.

82 Roses in a vase, 1882-3. 54×33 cm. Zurich, private collection.

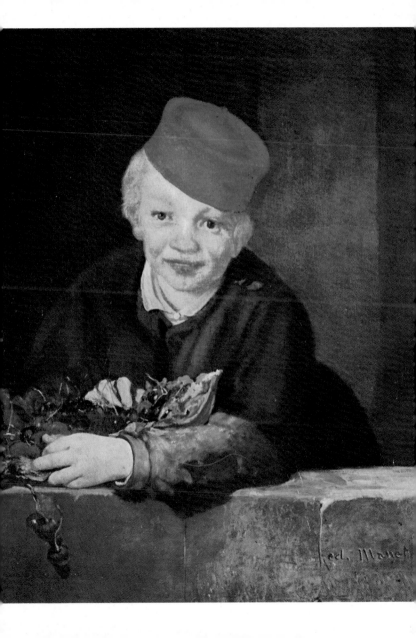

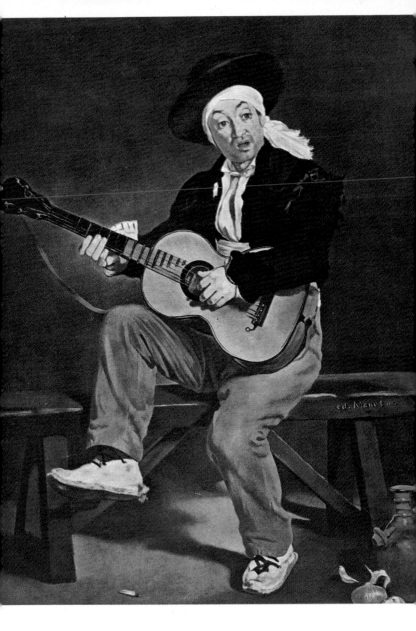

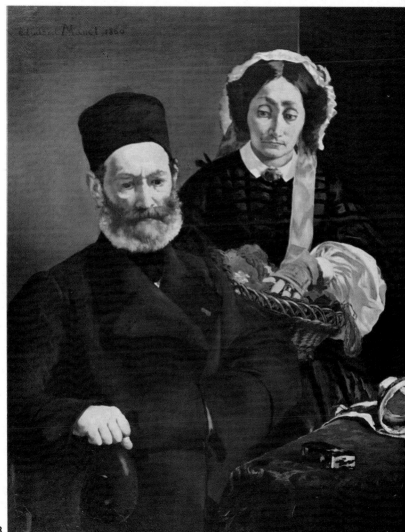

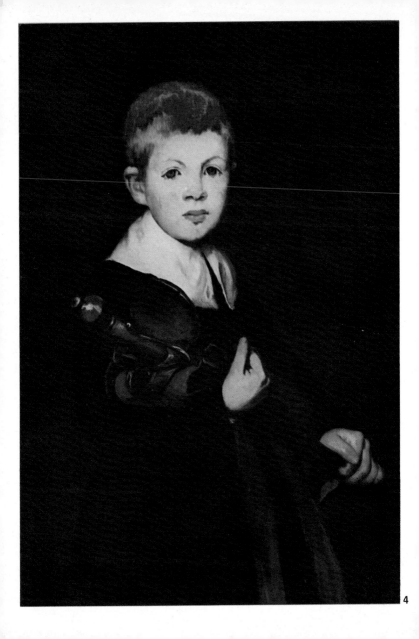

4

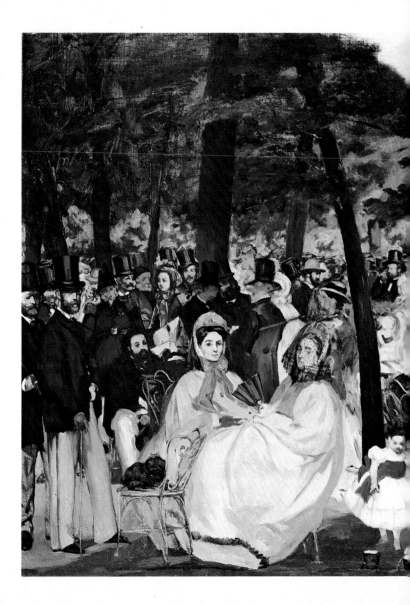

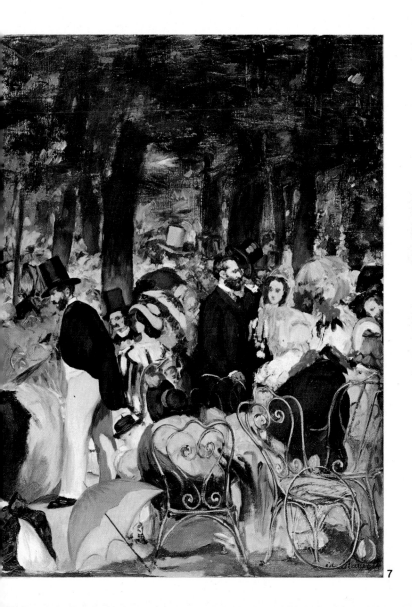

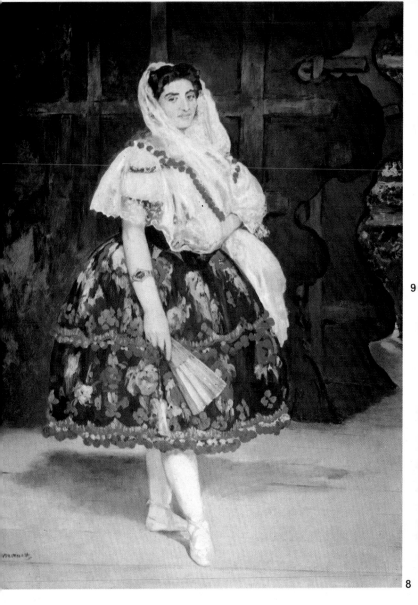

9

8

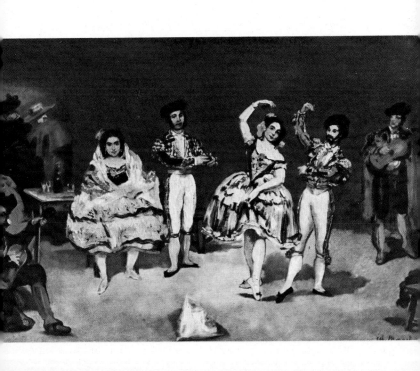

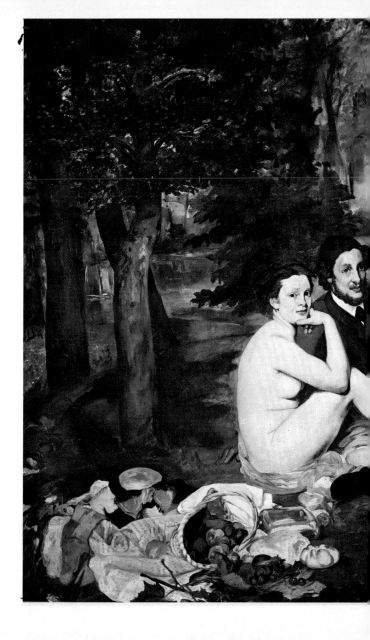

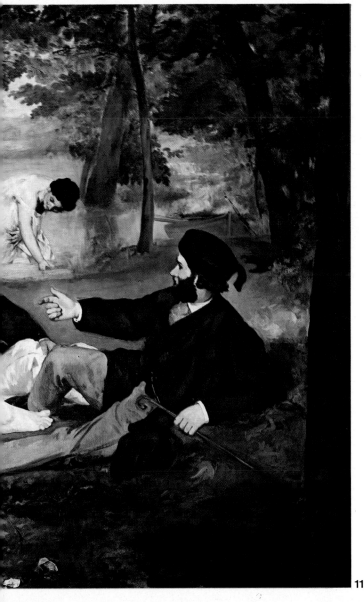

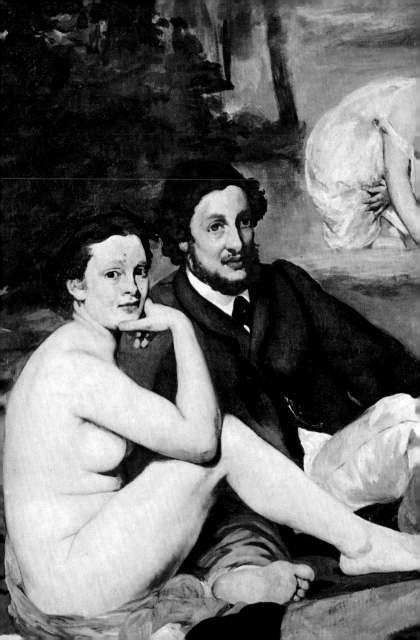

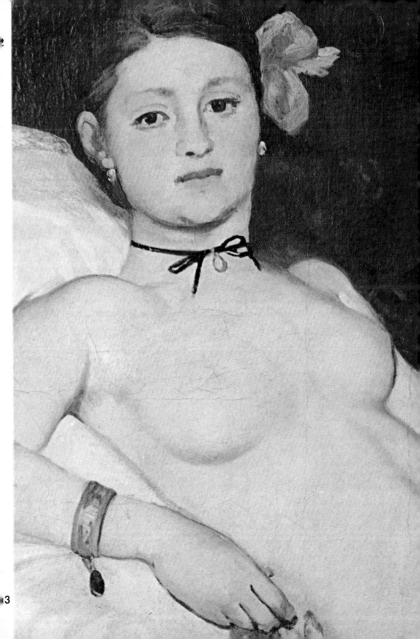

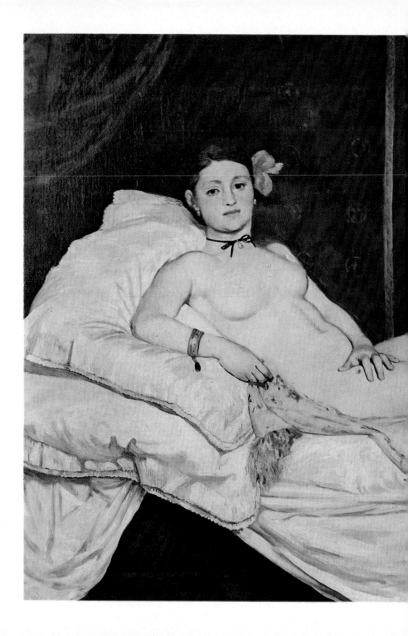

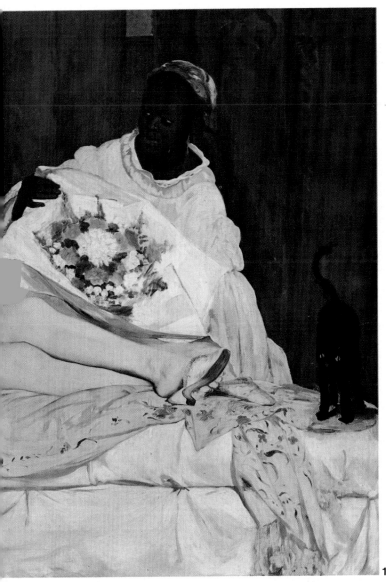

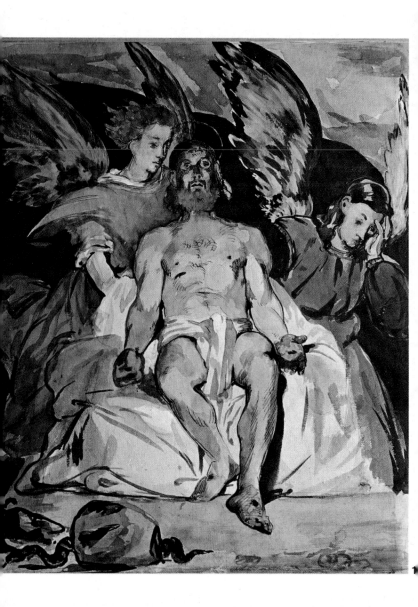

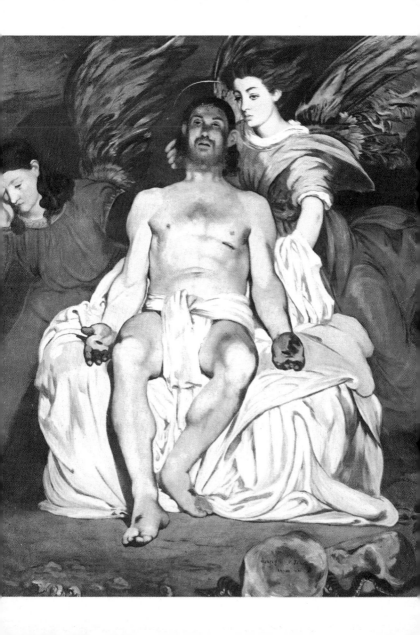

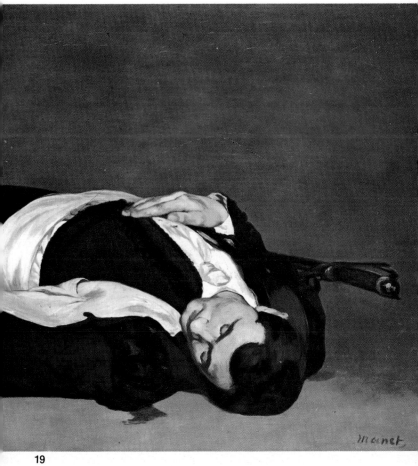

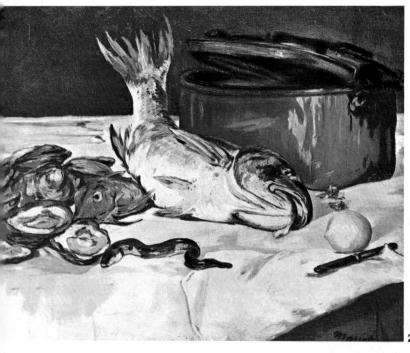

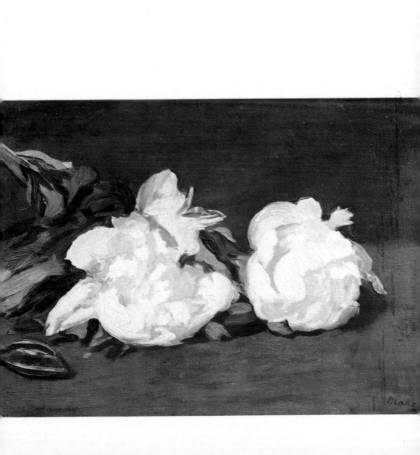

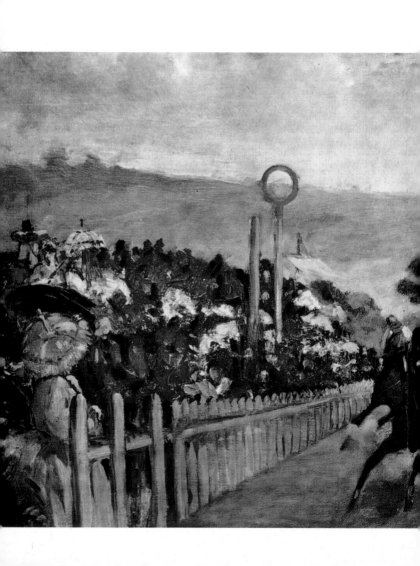

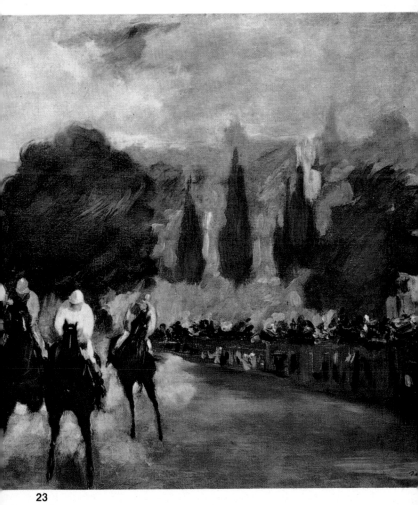

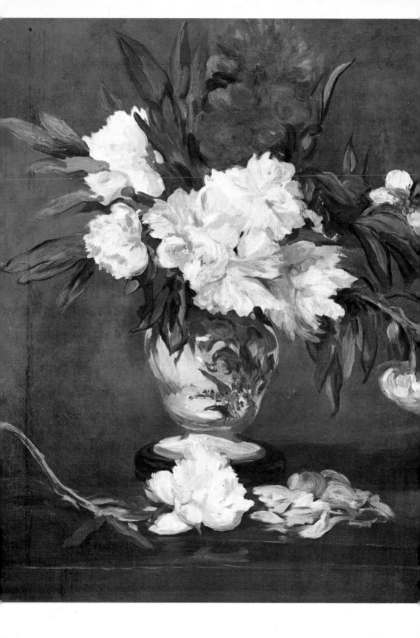

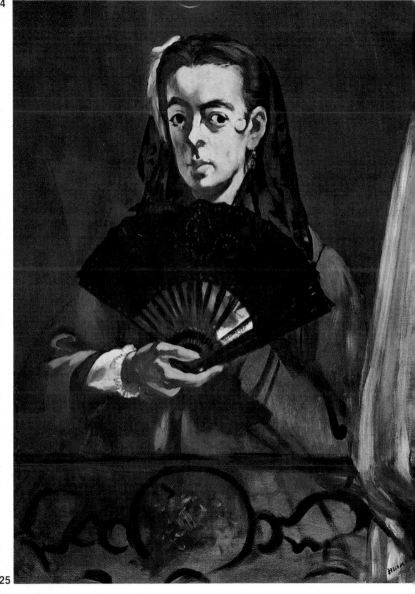

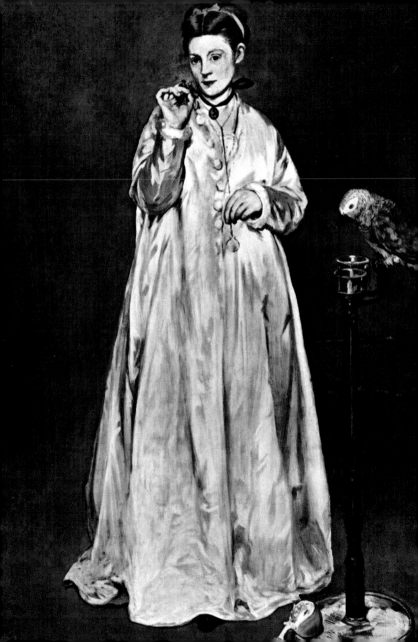

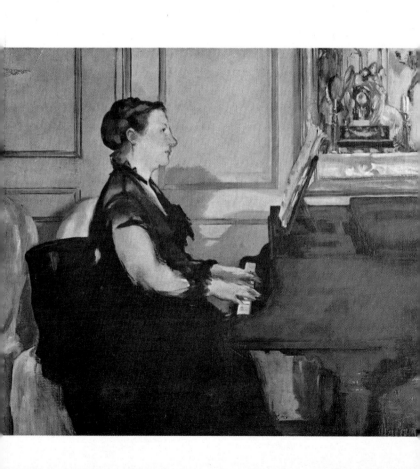

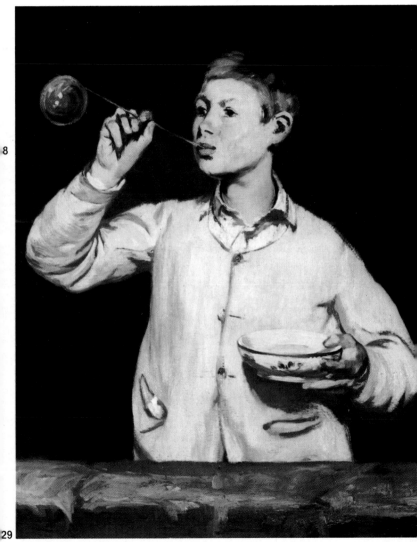

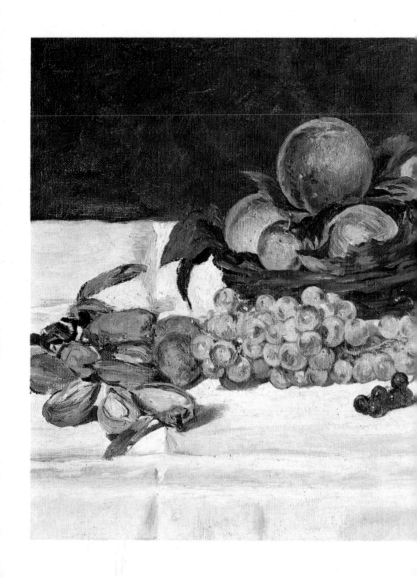

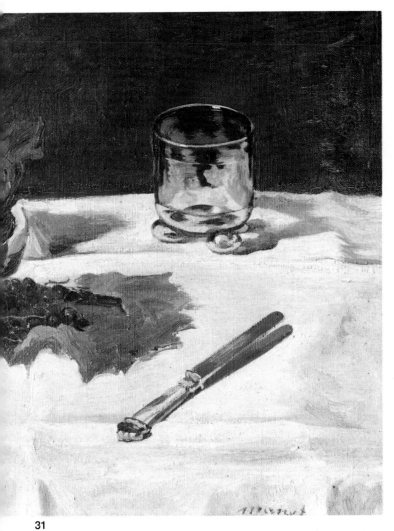

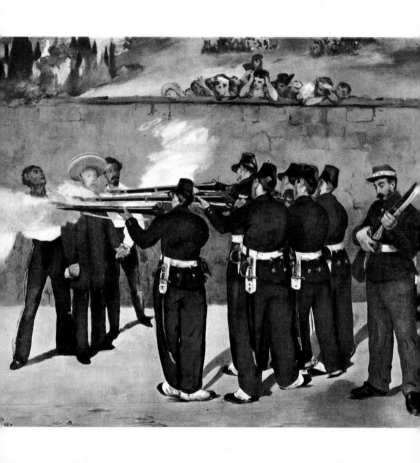

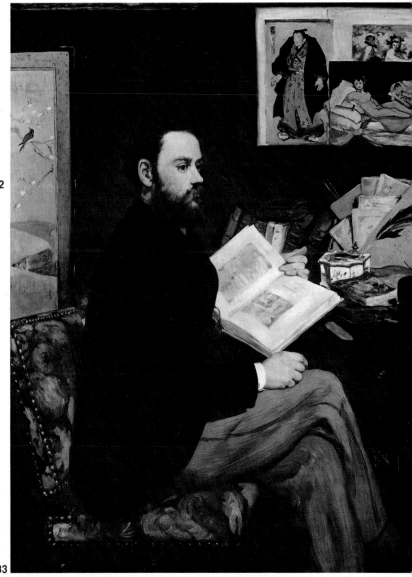

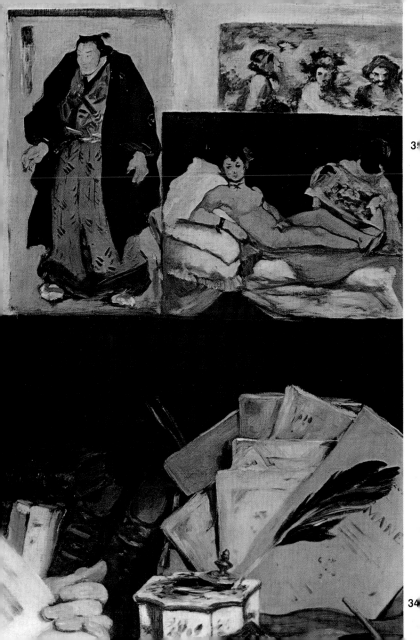

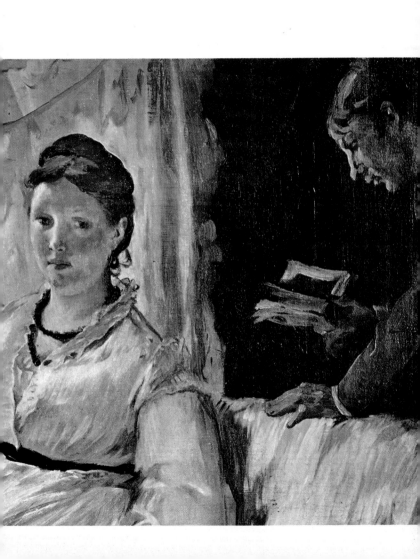

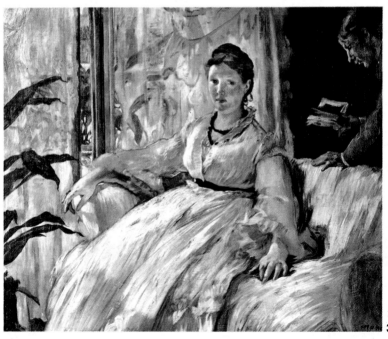

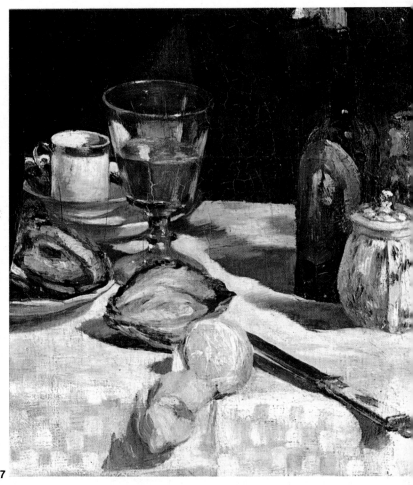

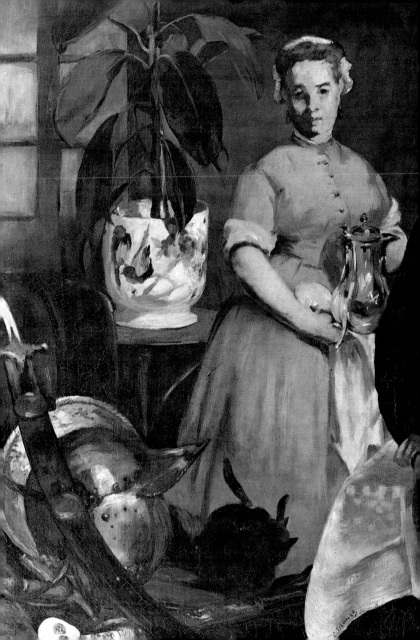

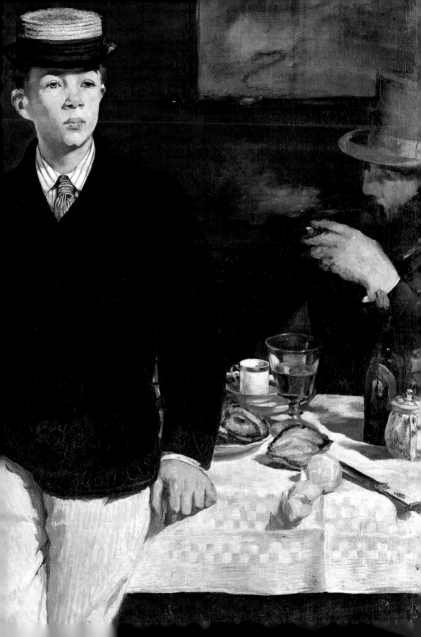

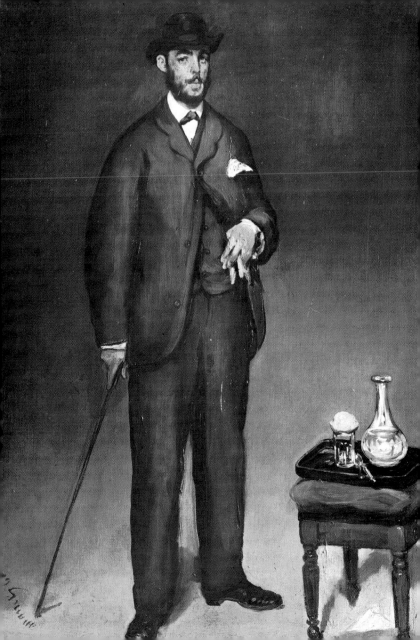

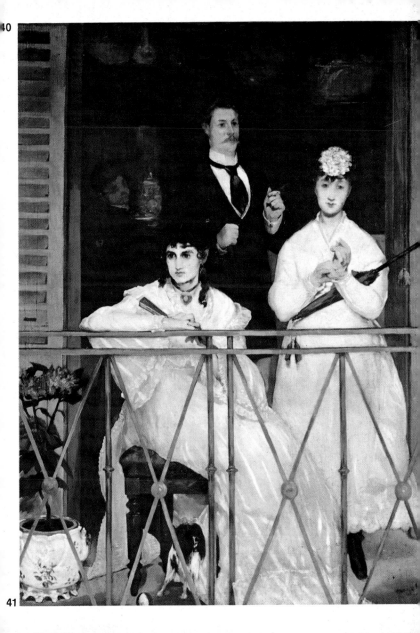

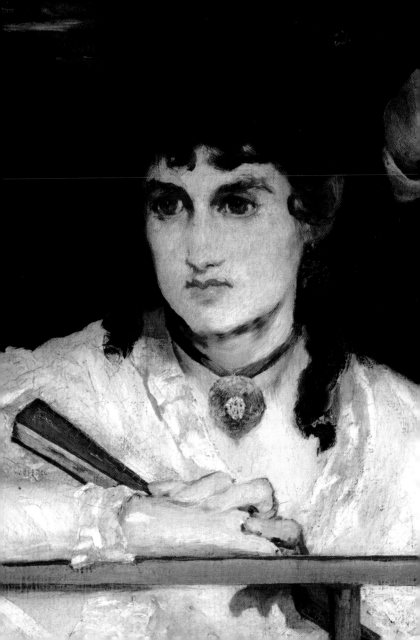

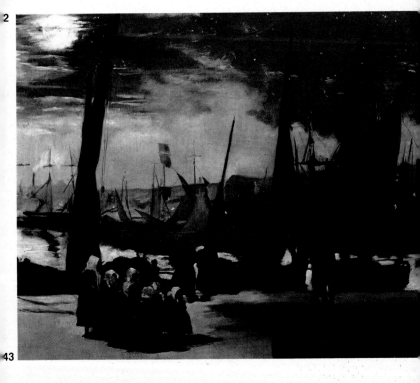

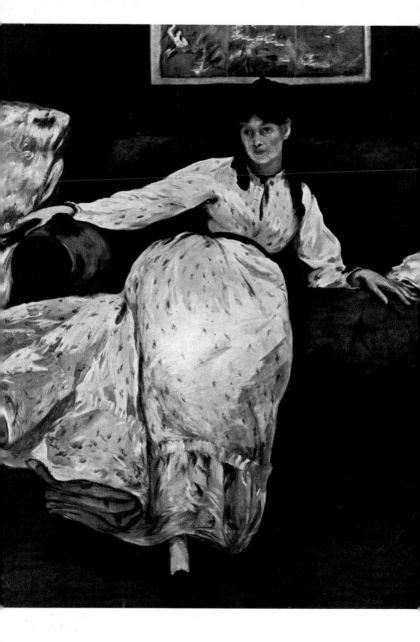

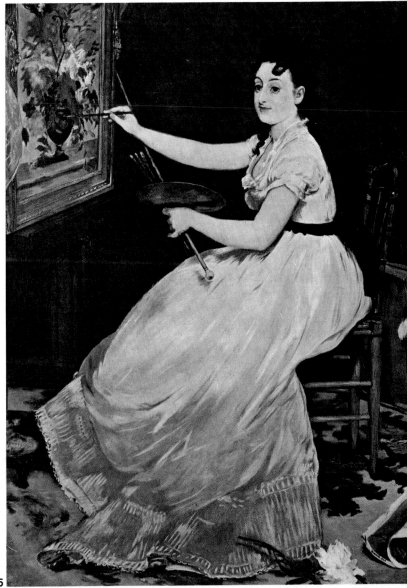

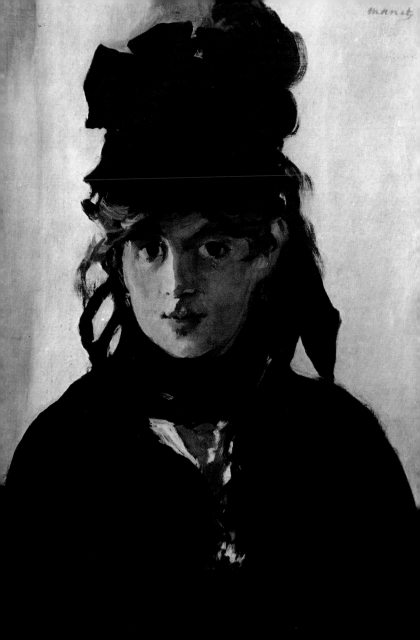

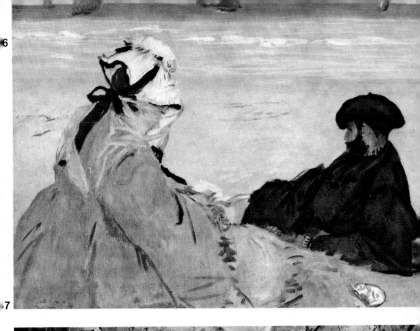

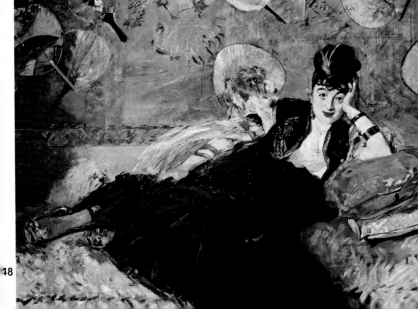

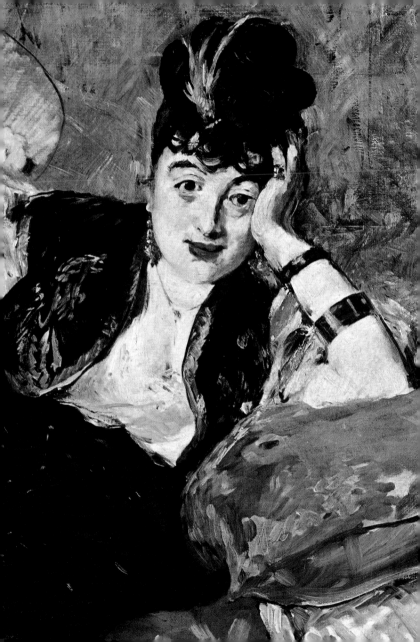

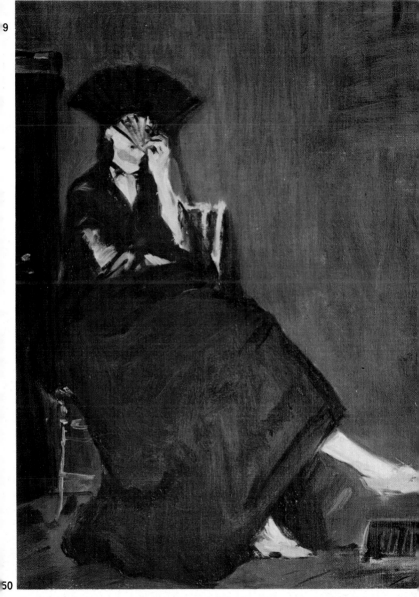

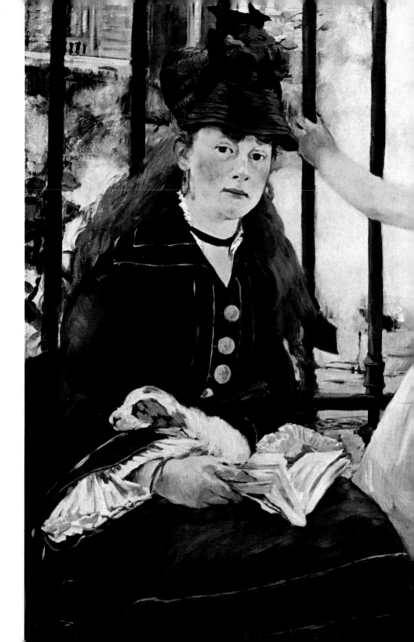

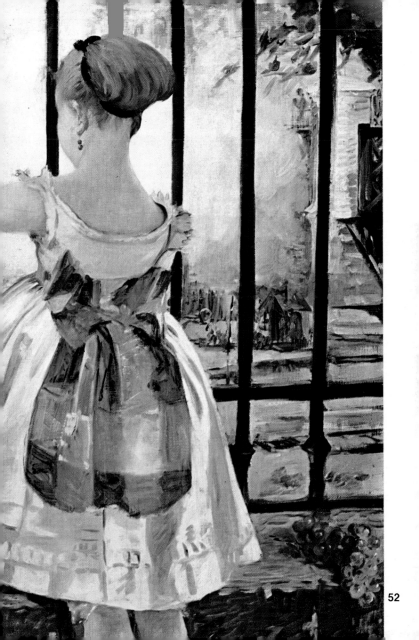

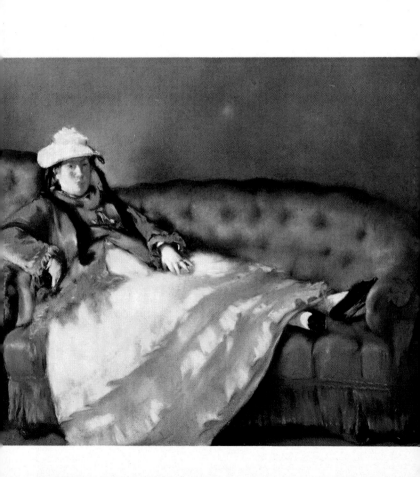

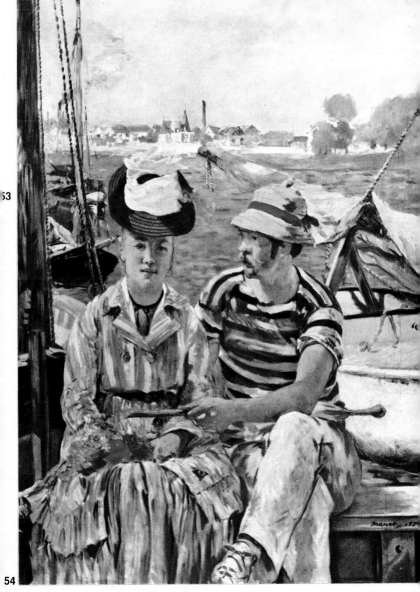

53

54

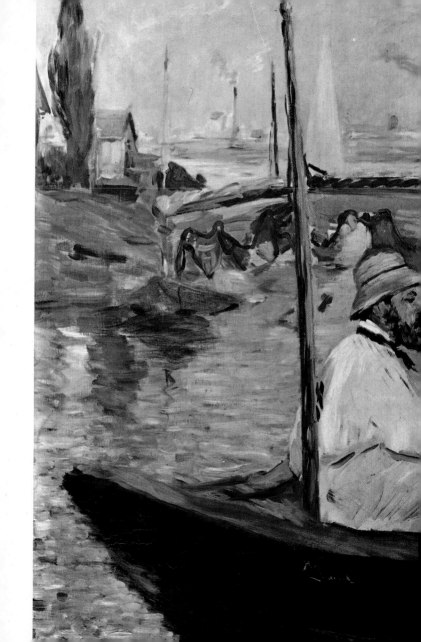

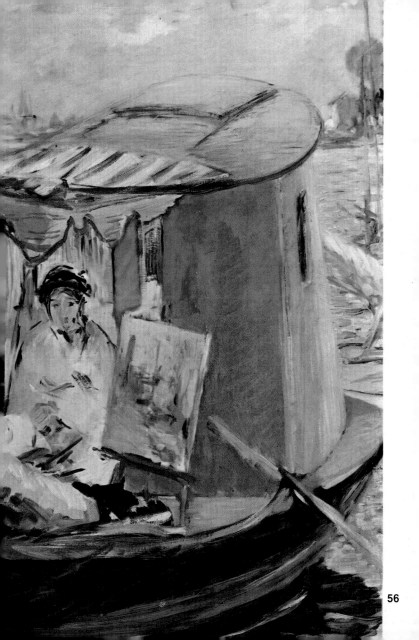

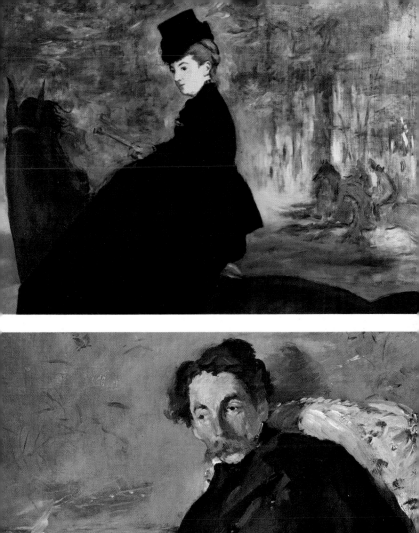

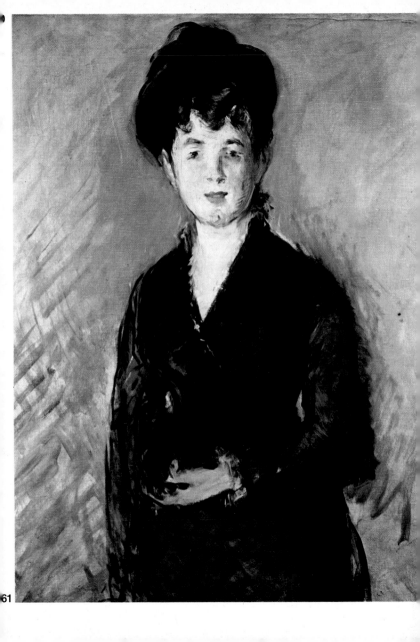

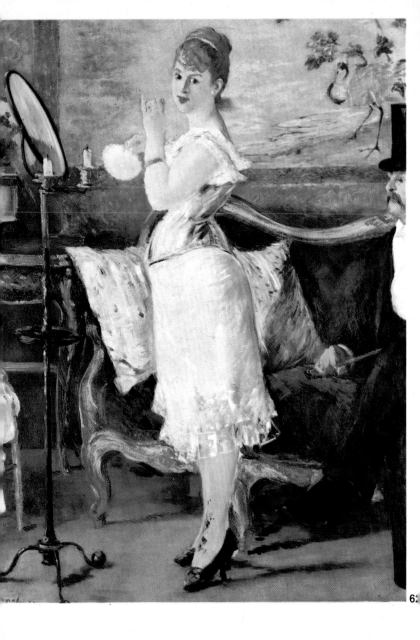

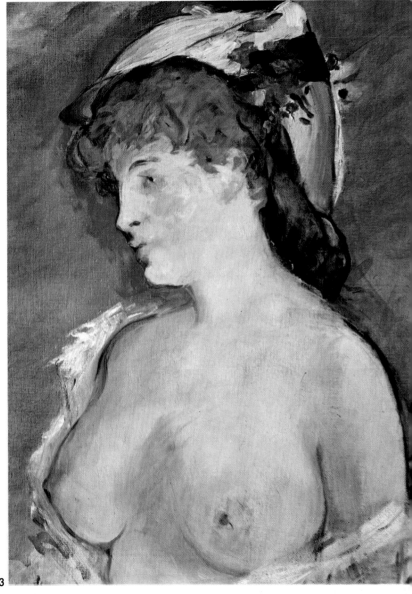

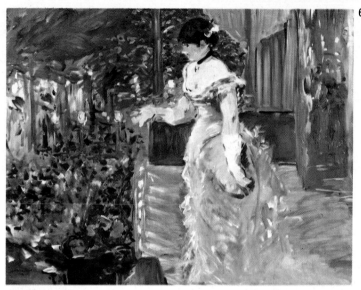

64

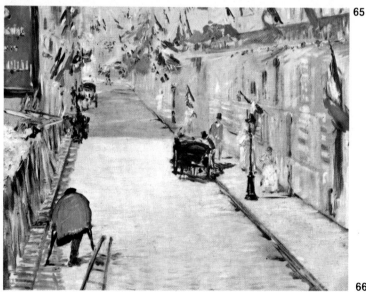

65

66 →

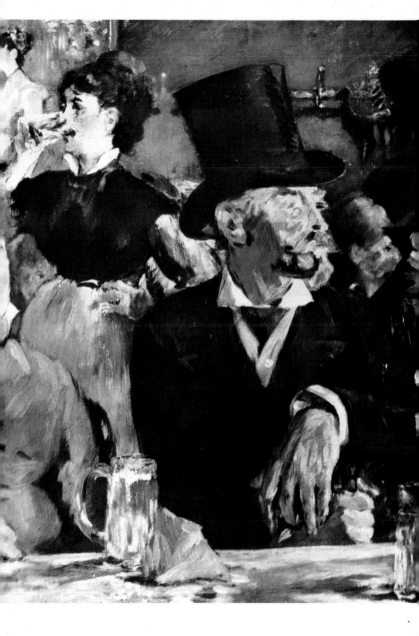

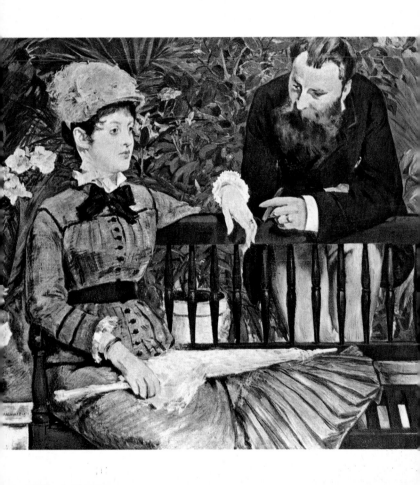

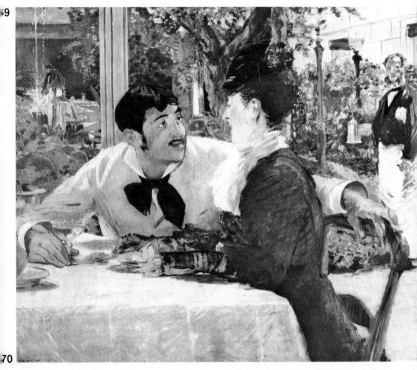

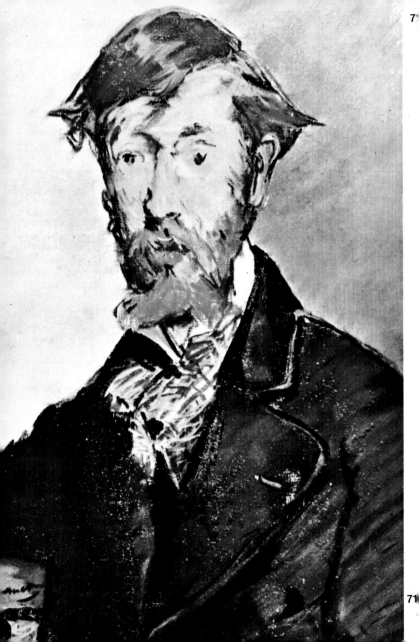

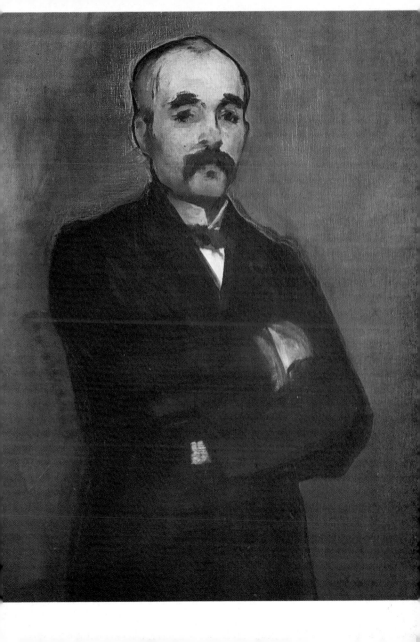

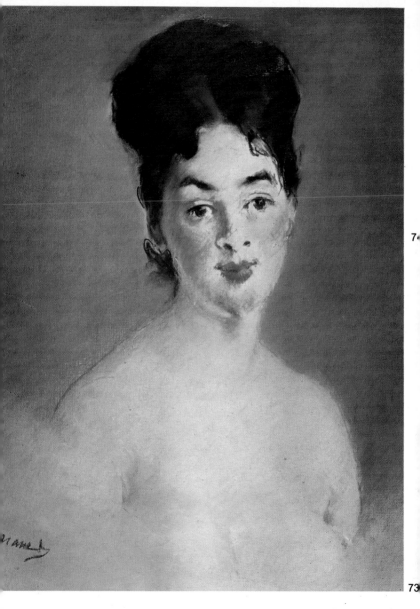

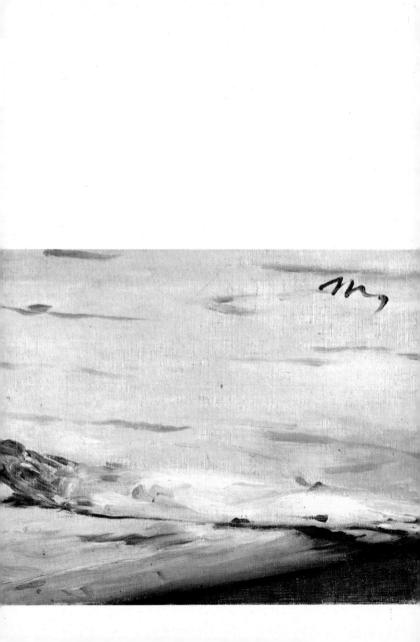

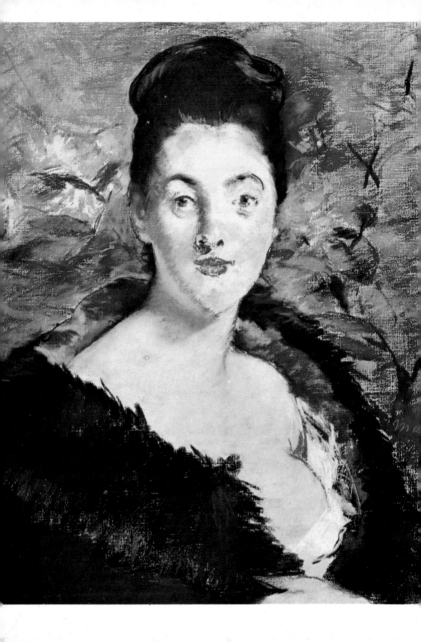

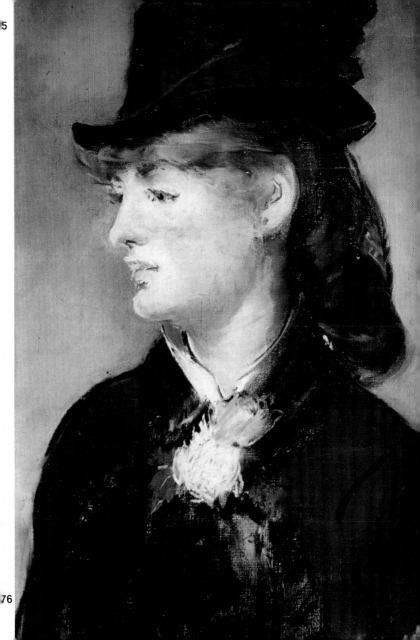

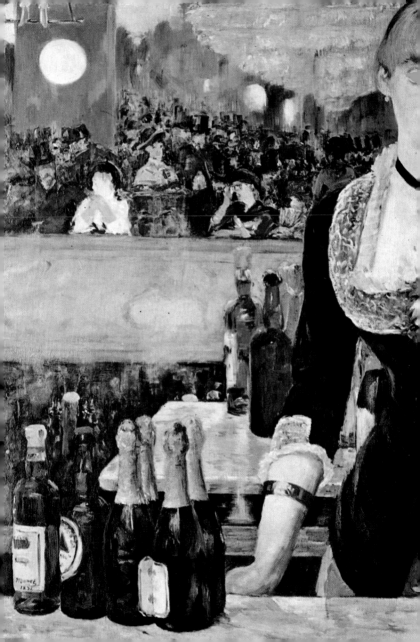

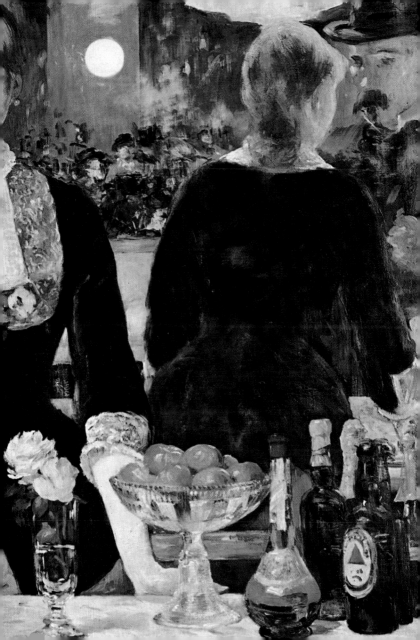

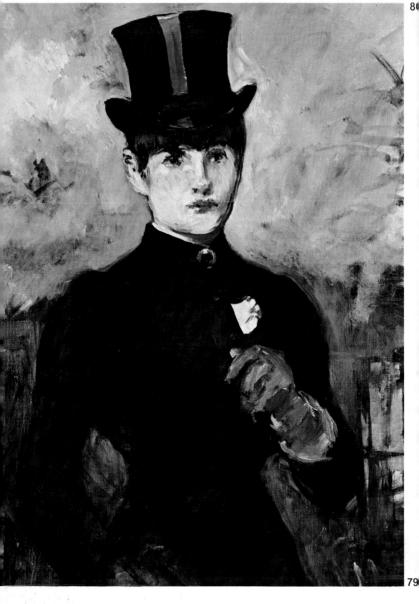

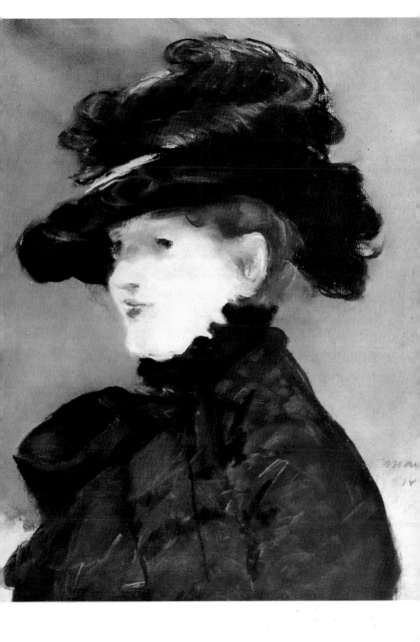

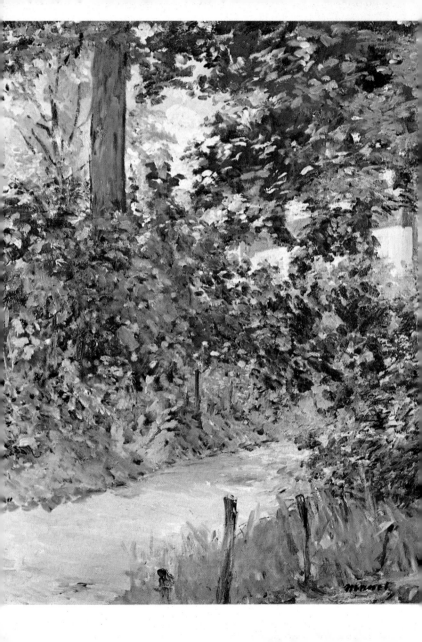

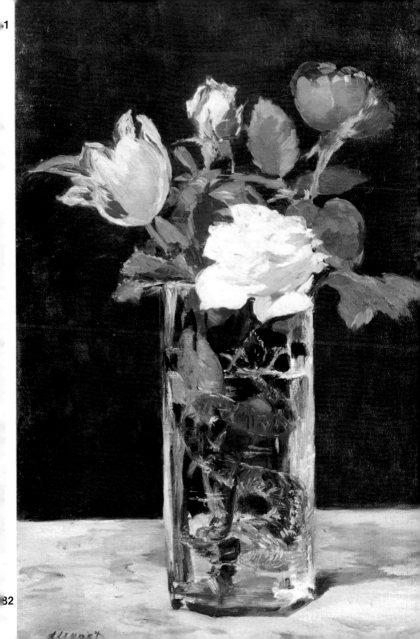